Murakami T

THE T-SHIRTS I LOVE

HARUKI MURAKAMI

Murakami T

THE T-SHIRTS I LOVE

村上 T

HARUKI MURAKAMI

TRANSLATED FROM THE JAPANESE BY
PHILIP GABRIEL

ALFRED A. KNOPF *NEW YORK 2021*

THIS IS A BORZOI BOOK PUBLISHED BY ALFRED A. KNOPF

English-language translation copyright © 2021 by Haruki Murakami

Portions of this work originally appeared, some in slightly different form, in *Popeye* from August 2018 to January 2020.

Interviews by Kunichi Nomura. Used by permission. The 2018 interview originally appeared as "Special Interview: Talking About T-shirts with Haruki Murakami" in *Popeye* (August 2018).

Photographs by Yasumoto Ebisu. Used by permission.
Frontmatter photography (T-shirt tag) by Chip Kidd

Library of Congress Cataloging-in-Publication Data
Names: Murakami, Haruki, [date] author. | Gabriel, Philip, [date] translator.
Title: Murakami T : the t-shirts I love / Haruki Murakami ;
translated from the Japanese by Philip Gabriel.
Other titles: Murakami T. English
Identifiers: LCCN 2021010295 | ISBN 9780593320426 (hardcover) |
ISBN 9780593320433 (ebook)
Subjects: LCSH: Murakami, Haruki, [date] | Authors, Japanese—
20th century—Biography. | T-shirts—Collectors and collecting. |
T-shirts—Pictorial works. | LCGFT: Essays.
Classification: LCC PL856.U673 M8713 2021 | DDC 895.6/35 [B]—dc23
LC record available at https://lccn.loc.gov/2021010295

Jacket art, design, and photography by Chip Kidd

Manufactured in China
First United States Edition

33614082478743

Contents

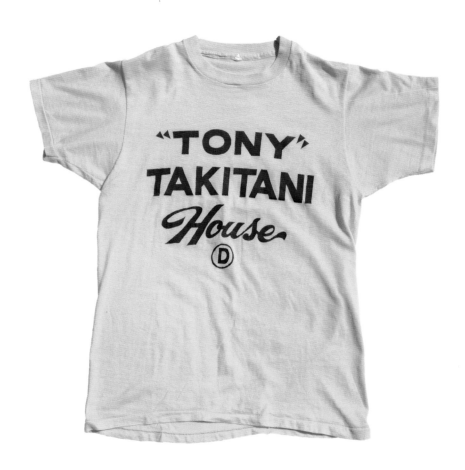

T

1

Preface:
The Things I End Up Collecting

I'm not particularly interested in collecting things, but there's one sort of running motif in my life: despite my basic indifference, objects just seem to collect around me, of their own volition. Stacks and stacks of LP records—so many I'll never listen to them all; books I've already read and will probably never open again; a ragtag assemblage of magazine clippings; dinky little pencils so worn down they don't fit into a pencil sharpener anymore—all kinds of things just keep on piling up. Like the character Urashima Taro in the Japanese fairy tale, who can't help himself from rescuing a little

turtle on the beach, I find myself somehow resigned to it. Carried away by some emotion I can't even name, I wind up gathering things around me. Though I'm well aware that collecting hundreds of stubs of pencils doesn't serve any possible purpose.

T-shirts are one of those objects that just naturally pile up. They're cheap, so whenever an interesting one catches my eye, I invariably buy it—plus people give me various novelty T-shirts from around the world, I get commemorative T-shirts whenever I finish a marathon, and I pick up a few at my destination when I travel, instead of bringing along extra clothes . . . Which is how, before I even realized it, the number of T-shirts in my life has skyrocketed, to the point where there's no room in my drawers for all of them anymore and I've had to store the overflow in stacked-up cardboard boxes. It's not at all like one day I simply made up my mind that *Okay, I'm going to start a T-shirt collection.* Believe me, that's not the case.

But now that I've lived this long, and find myself

with enough T-shirts to write a whole book about them, frankly it seems kind of scary. People talk about "continuity as key," and they're spot on. I get the feeling like that's all I've relied on in my life.

The Japanese magazine *Casa BRUTUS* interviewed me about my record collection for a special music edition, and when I happened to mention that I also kind of have a T-shirt collection the editor asked me if I'd consider writing a series on that. So I went along with the idea, and over the course of a year and a half, I wrote a series of essays spotlighting T-shirts in *Popeye*, a Japanese men's fashion magazine published by the same company. These are the essays collected here in this volume. It isn't like these are valuable T-shirts or anything, and I'm not claiming they have any particular artistic value. I simply brought out some old T-shirts I'm fond of, we took photos of them, and I added some short essays. That's all there is to it. I doubt this book will be that useful to anyone (much less being of any help in solving any of the myriad problems we face at

present), yet, that said, it could turn out to be meaningful, as a kind of reference on customs that later generations could read to get a picture of the simple clothes and fairly comfortable life one novelist enjoyed from the end of the twentieth century into the beginning of the twenty-first. But then again—maybe not. Either way works for me. I'm just hoping you can find some measure of enjoyment in this little collection.

Of all my T-shirts, which one do I treasure most? That would have to be the Tony Takitani shirt. I ran across this T-shirt in a thrift shop in Maui and bought it for about a dollar. I asked myself, "What kind of person could Tony Takitani be?" and let my imagination take over, and I actually ended up writing a short story with him as the protagonist, which later was made into a film. And the T-shirt was just one dollar, if you can believe it! I've made a lot of investments in my life, but this was, hands down, the absolute best.

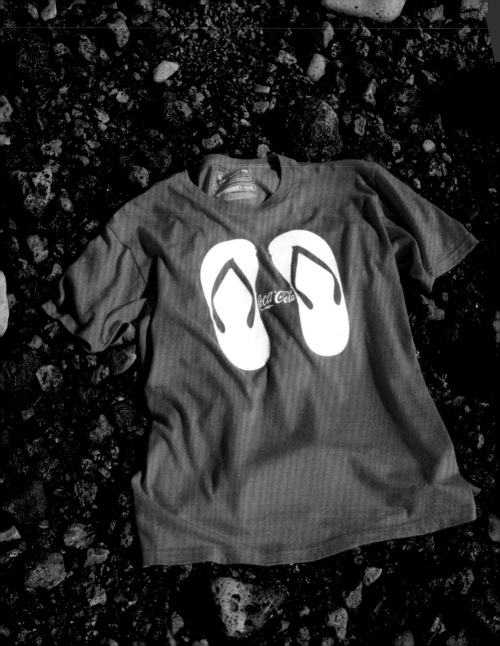

In the Summer, You Gotta Go Surfing

THIS WAS A LONG, long time ago. The 1980s, to be exact. I'm a little embarrassed to admit it, but back then, I surfed for a few years. When I lived in Kugenuma in Fujisawa City, a guy I knew in the neighborhood was crazy about surfing (there were a lot of people like him there), and he invited me to try it. I rode a long board in the ocean off Kugenuma, but when I visited Hawaii, I used to rent a Dick Brewer short board, and surfed the waves every day off the beach at the Sheraton—blissfully, if a bit tentatively. Nearly every

morning found me in the ocean, then at noon I'd go back to my room, and make some chilled *hiyamugi* noodles for lunch. I did hardly any work and just enjoyed some laid-back, lazy time. That was a fun life I had back then! I remember hearing Paul McCartney and Michael Jackson's song "Say Say Say" on the radio a lot that summer.

A few years later, I was looking for a house on the north shore of Kauai, and the well-built older man who showed me around some places was named Richard Brewer. "Oh, so you have the same name as that famous surfboard shaper," I said to him. "I guess there's no need to hide it," he replied, "but I am that Dick Brewer." He sounded a little embarrassed to admit it.

Huh? That famous Dick Brewer working at a real estate agency out in the middle of nowhere in Kauai? Why? I asked. "To be honest," he said, "I don't want to do this kind of work, but my wife told me I'll never get ahead if all I do is keep on surfing the rest of my

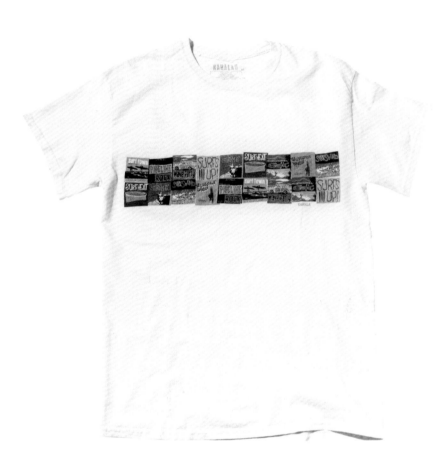

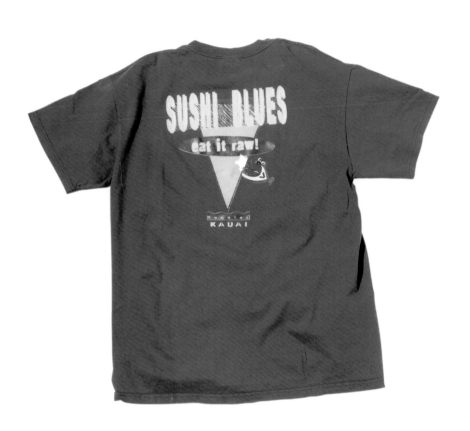

life. She told me to work hard from now on selling real estate, so here I am. What're you gonna do?"

I kind of felt sorry to hear this. He told me that whenever the weather's nice and the surf is good, the old excitement grabs him and it's hard to focus on selling houses. So he'd sneak away to the beach and watch the waves. Totally understandable. At the same time, I can also sort of understand being afraid of your wife's reaction. I recall we shared a couple of beers and commiserated with each other. He was a really nice guy. I didn't end up buying a house from him, though.

Recently, I looked him up on the internet and it said that in the 1960s he was known as a big-wave surfer, one of the top surfers at the time in Waimea Bay and Sunset Beach. It must have been a happy way to spend his youth. I wonder how he's doing now.

Three of the T-shirts in the photos are connected with surfing. The red one shows a beach sandal, a Coca-Cola kind of summer. A nice image. The white T-shirt shows the record jackets of a lot of '60s-era surf

albums. Brings back lots of good memories. The Sushi Blues T-shirt is from a unique sushi shop that was in Hanalei on the north shore of Kauai years ago. You could listen to live blues music while enjoying sushi. Is it still there? Hanalei back then was a great place, totally laid-back. I never got tired of lazing around on the beach, watching the waves and the clouds. And the sunsets were amazing. Guys with ukuleles would gather on the beach and serenade the setting sun. I wonder if things there are still like that?

Greg Noll is a famous long board shaper. I like the design of this T-shirt and wear it a lot.

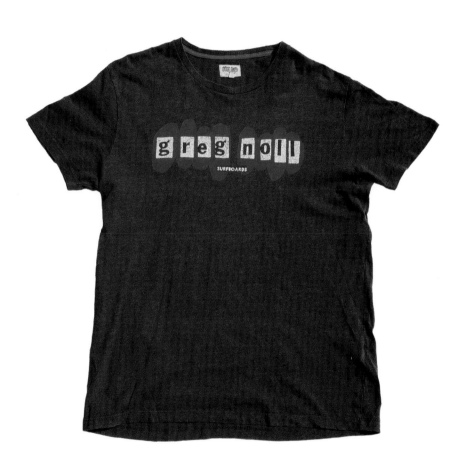

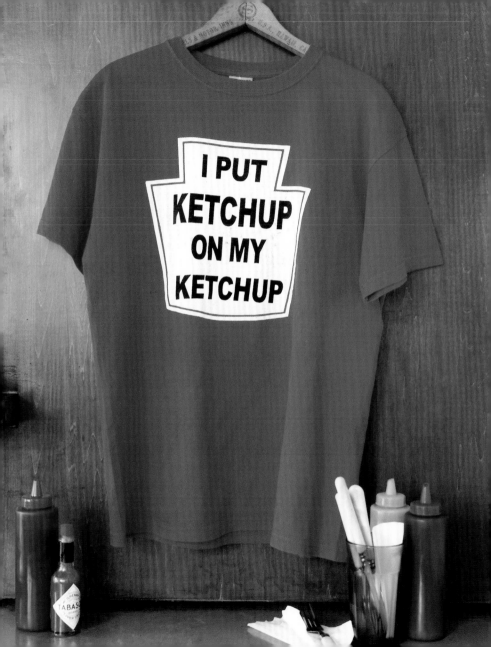

Hamburgers and Ketchup

WHENEVER I GO to the U.S., after I pass through customs, leave the airport, and get settled in town, I invariably find myself wanting to go out and grab a hamburger. How about you? At least *I* get that feeling. It's kind of an instinctive reaction, but you could also see it as just a formality. Either one's okay. At any rate, off I go in search of a hamburger.

Ideally, I go to a hamburger joint around 1:30, after the lunch crowd has left, plunk myself down at the counter, and order a Coors Light on tap and a cheeseburger. I like the burger medium, and I always get raw

onions, tomatoes, lettuce, and pickles. Plus an order of French fries and, like revisiting an old buddy, a side of coleslaw. Critical partners in all this are mustard (it's got to be Dijon) and Heinz ketchup.

I sit there, quietly sipping my Coors Light, listening to the voices of the people around me, the clatter of dishes and glasses, attentively imbibing the atmosphere of this different land, as I wait for my cheeseburger to emerge. As I go through this process, it finally hits me that yes, I really *am* in America.

Doesn't your mouth water just imagining that scene?

Recently there are a lot of places in Japan, too, that can make an authentic hamburger, definitely something to be celebrated—yet casually eating a burger, like it's nothing special, in some random place in the U.S. has a kind of special flavor all its own, quite aside from whether it tastes all that great or not.

The first T-shirt has a straightforward message: I PUT KETCHUP ON MY KETCHUP. Now that's somebody seriously in love with ketchup. It's kind of teasing

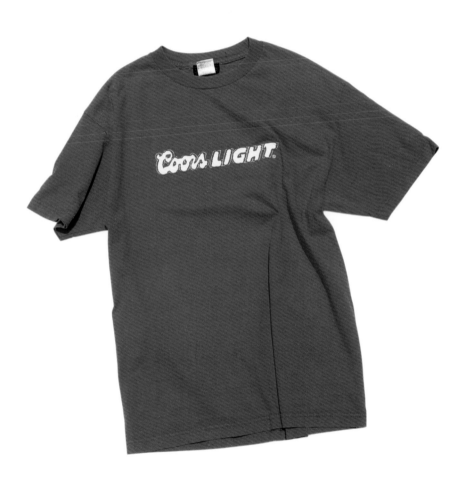

Americans (some of them) who put ketchup on everything, but I find it interesting that the company that distributes these shirts is none other than the ketchup manufacturer Heinz. A little self-deprecatory humor going on here, you might say, but you can't help feeling the American spirit in the message, the sort of optimistic, cheerful lack of introspection that says, "Who cares about being sophisticated! I'm gonna do what I want!"

When I wear this shirt and walk around town, Americans sometimes call out, "Love the shirt!" The ones who do are usually serious, slightly overweight individuals who definitely have that "I love ketchup" look about them. Sometimes I feel like coming back with a "Hey, don't lump me together with you guys," but usually I just give a cheerful "Yeah, pretty nice, huh? Ha-ha." This sort of T-shirt communication does a lot to liven things up. You'd never find that happening in Europe. For one thing, Europeans by and large hardly ever eat ketchup.

With hamburgers, I've got to have ketchup, Tabasco, and pickles—but is this Brooklyn Pickle shirt from a pickle shop? The store's in Syracuse, but beyond that I have no idea what it's about. (Later on, a reader pointed out that it is a deli and sandwich shop in Syracuse.)

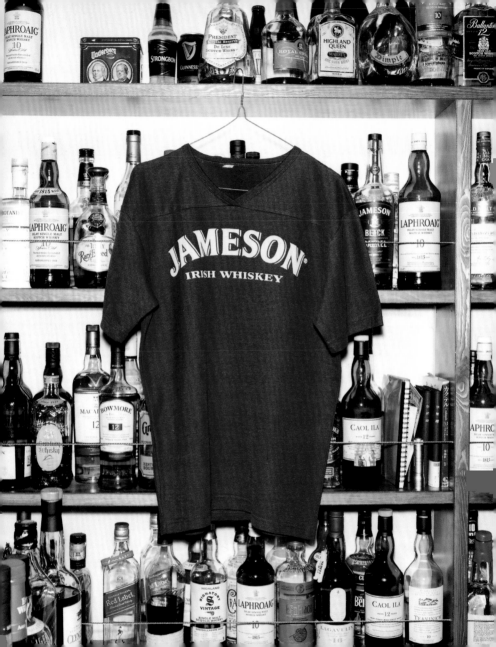

Whiskey

DO YOU LIKE WHISKEY? Put me down as a fan. It's not like I drink it every day, but if the situation arises, I have been known to raise a glass.

Especially late at night, when I'm alone and listening to music, whiskey seems the perfect accompaniment. Beer's a little too watery, wine's a bit too refined, a martini too pretentious, brandy too mellow. The only choice is to bring out a bottle of whiskey.

I generally am an early-to-bed, early-to-rise type, but on the rare occasion that I do stay up late, it's usually with a whiskey glass in hand. Listening to old

T

familiar LPs on the turntable. For me, it's got to be jazz. And not a CD. Old-school vinyl records fit the mood better.

If a bar has particularly tasty ice, I might have it on the rocks, but these days, when I drink at home, I usually have it Twice Up. It's easy to make. Just pour the whiskey into a glass (I prefer more formal stemware), and add an equal amount of water (at room temperature). Swirl the glass to get the two to mix and you're good to go. Couldn't be simpler.

When I visited the island of Islay in Scotland, the locals insisted that this is the best way to drink whiskey, and ever since, that's the way I've enjoyed it. I don't want to sound preachy, but if you drink whiskey this way, you can enjoy it without losing any of its innate flavor. The local water in Islay has a special aroma that complements its single-malt whiskey. If you drink the same whiskey with Japanese mineral water, the taste is slightly different. Call it the power inherent

in a place or whatever, but it's something that can't be helped.

Maybe it goes without saying, but this simple Twice Up way of drinking works even better the higher the quality of the whiskey, and the more robust the flavor. I mean, you're not about to take a twenty-five-year-old Bowmore single malt and make a highball with it and chug it down, are you? People are free, of course, to drink it any way they like (and I myself enjoy a Jingu Highball, a specialty of the stadium, when I go watch a ball game at Jingu Stadium).

I also stayed on Jura, a tiny island next to Islay. They have a famous single-malt distillery there as well, and the local water is equally tasty, though with a different flavor than Islay's. Drinking it mixed with the local Jura whiskey made for a one-of-a-kind flavor. I stayed at the distillery's lodge, drank as much whiskey every day as I liked, enjoyed the local cuisine . . . Just spending a few days there made it feel like life was worth living.

I have quite a few T-shirts made by whiskey com-
panies at home, though wearing a whiskey T and
walking around in the morning seems a bit much . . .
People might take me for some old drunk. Which is
why these shirts in the photos are ones that, unfortu-
nately, I seldom wear.

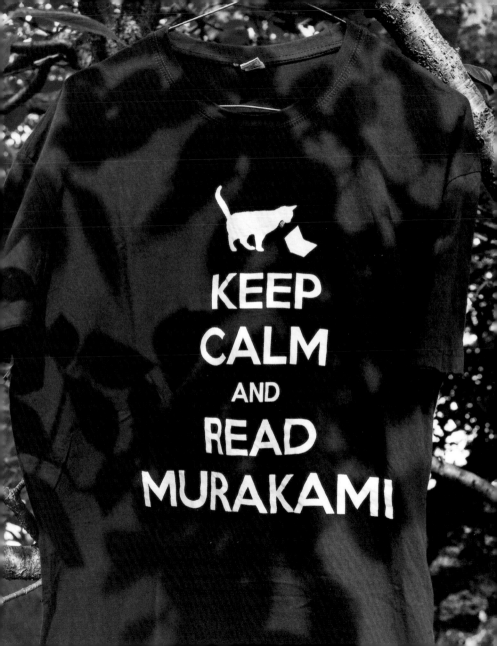

Keep Calm and Read Murakami

THEY DON'T DO THIS much in Japan, but often, when a book of mine's published abroad, they'll create promotional T-shirts, tote bags, baseball caps, and so on. The local publisher sends me some of these goods, and they've piled up over the years. Maybe one whole cardboard box full.

All well and good, but I'm not about to wear one of those T-shirts around town. I mean, Haruki Murakami himself isn't about to stride down one of the main streets in Tokyo in the middle of the day wearing a T-shirt loudly proclaiming HARUKI MURAKAMI on it,

now, is he? Or carry one of those tote bags with him when he goes shopping at a used-record store. Right? Which is why all those promotional goods are, as we speak, sound asleep in a cardboard box in the back of my closet. Kind of a shame, really, since the publishers went to all the trouble of making these T-shirts, and I've never even worn them. Maybe in a hundred years they'll be treasured relics, *unusual data from the past.*

The "Keep Calm" T-shirt was made a few years back by a Spanish publisher. KEEP CALM AND READ MURAKAMI—I like that. A great slogan. It's based on the British Ministry of Information's famous poster that read KEEP CALM AND CARRY ON. It was a slogan they came up with at the onset of the Second World War, to encourage people not to panic. People have been revisiting that slogan recently, and it's become quite popular again. For instance, at the time of the 2008 economic crisis, some investment companies ordered huge amounts of posters with this slogan. Didn't exactly work, though.

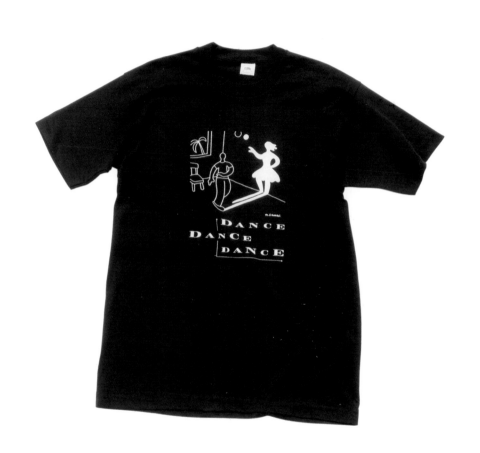

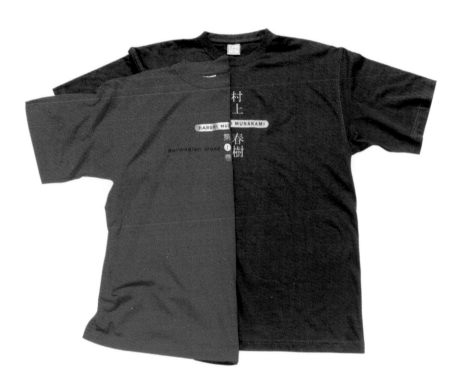

This slogan has been repurposed here, too, on this shirt. The cat's kind of cute, but even with that on it, I'm not about to wear it myself. Leaving that aside, when the world's topsy-turvy and unsettled, getting comfortable with a good book is a pretty nice way to go. I encourage you to give it a try.

The *Dance Dance Dance* T-shirt was made when the book was published in the U.S. in the beginning of the 1990s. They used the cover illustration by Maki Sasaki. This must have been my first promotional T-shirt, so now it's a kind of memento that brings back old times.

The *Norwegian Wood* shirts were made by a U.K. publisher. They admired the way the Japanese editions were published in two volumes—one red and one green—and so when the English translation appeared in 2000, they went to the trouble of publishing it in a similar little two-volume boxed set, with one green book and the other red, and they made these matching two-colored T-shirts. I'm grateful to them for all the

effort they put into this, but again, there's no way I'm ever going to wear them. I mean, even if, say, a couple were to wear them as a paired set, they'd still stand out.

The last T-shirt is a promotional one for my disc jockey show on Tokyo FM radio. We used a wonderful illustration by the artist Masaru Fujimoto, though unfortunately Mr. Fujimoto later fell ill and passed away while still quite young. He was so talented, with a style all his own, and it's very sad that he's no longer with us. I do the radio program from time to time, so if you ever have the chance, please give it a listen. (A bit of self-promotion here!)

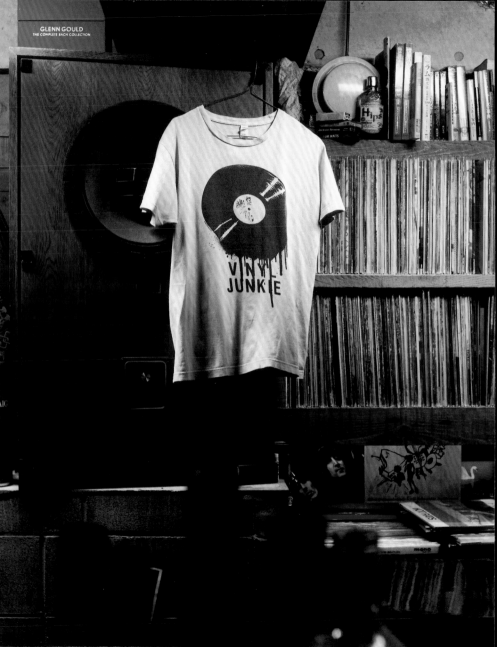

Record Stores Are a Blast

THE LONG AND THE SHORT of it is that I love record stores. Ever since I can remember, whenever I managed to save some money, I'd go record hunting. If I ran across one that I wanted, I'd skip lunches until I could afford to buy it. And now, more than a half century later, I can still be found out there, scouring stores for records. Rummaging around in a used-record store for an hour or so is, for me, one of the greatest pleasures life affords. Just gazing at a record I purchased, inhaling its smell, gives me a lot of joy.

I've visited record stores all over the world. I'm mainly a collector of jazz records, but if I can't find much in the jazz section, I look through the classical and rock records as well, and my record collection just keeps on ballooning. A bit of a bother, but it's a kind of addiction, you might say, an illness, so what're you going to do? It doesn't really do any harm . . . (I'm making excuses here.)

So, with all my roving around the world, from a used-record store point of view, which city has the most fascinating ones? New York would have to be number one. They have so many stores there, with impressive selections of records. And mostly, you can live with the prices. (Though the more exclusive stores can really be expensive.) Number two would be Stockholm. There are lots of ardent jazz fans in northern Europe—especially in Sweden—and they have a culture that really values records, so I came across some real finds there. I spent a week or so in Stockholm, most of it traipsing around in search of records, but

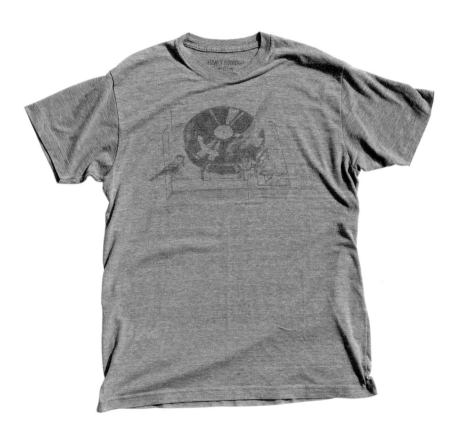

never grew tired of it. After I had gone to one store for three days straight (they had such an amazing inventory it took that long to look through all of it), the manager started to recognize me and asked, "Do you want to see some *real finds*?" I said I did and he took me into a back room and showed me a secret record shelf with a trove of records. Not something they show your average customer. And man, did they have some real gems there. I was in heaven.

The third-best city is Copenhagen. It's one step down from Stockholm, but they do have some amazing stores. You have to go to the suburbs to find them, so I borrowed a bicycle and pedaled from one to the other. The fourth-best city is Boston. I lived there for three years, so I was pretty knowledgeable about all the record stores in the area. Every week I made the rounds of twelve different stores. I'd drive, but in a big city like that, parking was always a problem. Often I'd be so engrossed in rummaging through the stacks I'd lose track of time, only to find that I'd gotten a parking

ticket. Then I'd have to write a twenty-dollar check and mail it to the City of Boston's parking department.

Used-record stores in Paris, London, Berlin, or Rome never did it for me. I searched around quite a bit, but hardly ever made any stellar finds. I wonder why.

Recently I traveled to Melbourne. I'd spent a month in Sydney a few years back, and searched for used-record stores but came up mostly empty-handed, which was disappointing. So I wasn't expecting much from Melbourne, but surprisingly—from a used-record store point of view—the place really rocks. Around the university there are rows of interesting used bookstores and record shops, and it was fun just strolling around the neighborhood. One used-record store was kind enough to put out a little map showing the location of the record stores, and the city tram was convenient, and I found it easy to get around. For my fellow record aficionados, I definitely advise a visit. The wine's pretty delightful too.

Another kind of unexpectedly interesting place for

records is Honolulu. They don't have that many specialized used-record stores, but I'd run across some amazing rare finds in thrift stores like Goodwill. At a dollar a pop. For instance, I found . . . This could take a while, so I'll save that for another time.

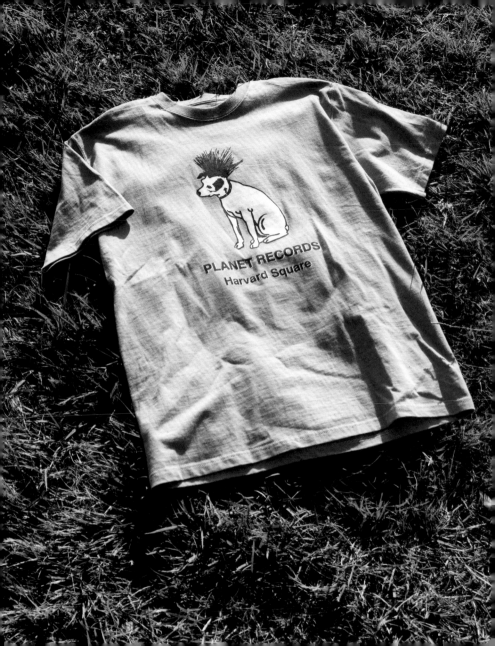

Animals Are Cute, but a Little Tricky

IF YOU WEAR A T-SHIRT with an animal design, the
chances are very good that a girl or woman will tell you,
"Whoa—that's so cute!" Nothing wrong with that, of
course, but I think you'd feel a little uncomfortable, as
if you'd deliberately worn the shirt wanting girls to tell
you how cute it is. In that sense, animal designs are a
bit tricky. But different from, say, a middle-aged Osaka
woman wearing a leopard print . . . So, the upshot is
that I rarely wear this kind of animal-design T.

When I look at them one by one like this, though, I
do have to admit it: they *are* pretty cute.

The shirt with a punk version of Nipper on it—the dog in the old "His Master's Voice" ads—is an original design from a used-record store, Planet, in Cambridge, Massachusetts. This shop is near the main gate of Harvard. They sell a lot of great T-shirts in the storefront, but I don't recall scoring many interesting records there. Much more appealing was the Indian restaurant Tamarind Bay nearby, a really stylish place to eat . . . Though that may be an irrelevant bit of info.

A long time ago, when I was in a movie theater watching the film *Mad Max 2*, there was a guy sitting right in front of me with a mohawk similar to the one Nipper wears on the shirt, and he kind of blocked my view of the screen. I'm not prejudiced against punks or anything, but at a movie theater, a mohawk does get in the way of your enjoyment.

The fox T-shirt is one I bought at a thrift store in Honolulu. I wasn't sure what the story was behind it, but later on I looked into it and discovered it's the title

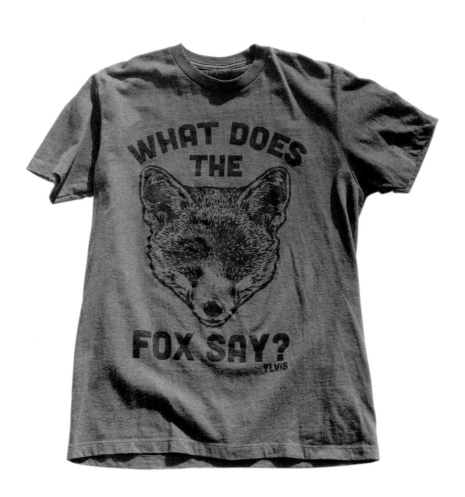

of a song from 2013, a worldwide hit. I watched it on YouTube, and frankly, it's kind of silly. So again, you'll seldom find me wearing this shirt.

I don't recall where I bought the Curious George shirt. I think I just found the drawing cute and went ahead and plunked down the money, though I've never had the courage to wear it in public. Maybe I could get away with wearing it on the beach in the Bahamas or somewhere, though I've never found the time to visit . . .

The last T-shirt was given to me by a friend, the late illustrator Mizumaru Anzai. The writing on the right says "sloth" in Japanese. Without that hint, you wouldn't be able to identify the creature hanging from a branch. Mizumaru often used this device. When he drew famous people, it was hard to tell who they were so he'd write their names beside them: *Musashi Miyamoto* (the famous swordsman), or *Lincoln*, and so on. Strangely enough, once you see the name you start

to see the resemblance—like, *Yeah, now that you mention it* . . . Mizumaru really did have a talent all his own.

All that to say that this is a *sloth*. Wear this and you can bet girls will tell me, "Whoa—that's so cute!" Have I worn it? Not yet.

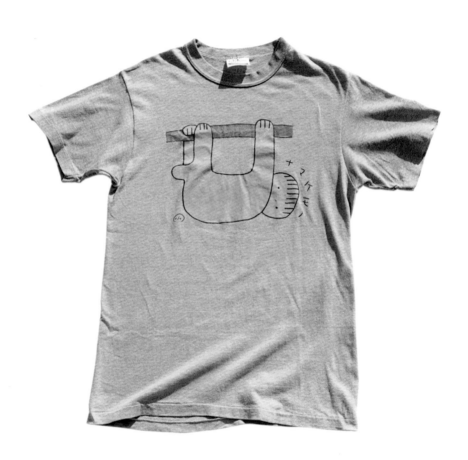

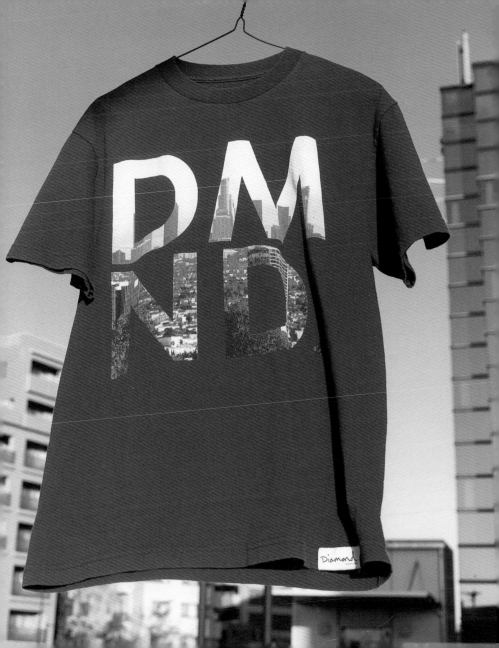

Meaning Unknown

THERE'S A PHOTOGRAPHER named Elena Seibert
who specializes in taking photos of writers, and when
I go to New York, I often visit her studio near the Vil-
lage to have my photo taken (at the insistence of my
publisher). Her specialty is taking updated photos of
writers, and as you might expect, she's excellent.

Every time I go, I bring along a variety of clothes
for possible use in the shoot, but solid-color T-shirts are
her all-time favorite. Her pet theory is that in a photo
shoot, nothing beats a plain, solid T-shirt. "Take a look

T

at the lovely portrait of Truman Capote in a T-shirt that Henri Cartier-Bresson took," she told me. I see her point, since it is an amazing photo.

Naturally I'm a fan of plain T-shirts myself, and they're my go-to, day-to-day choice, a close second being the kind of shirts shown here that have no images, just writing. These aren't T-shirts with some significant written message, but ones with a kind of random writing that make you shake your head, wondering what the heck it means. Unlike shirts with pictures on them, I don't get tired of looking at them, and with less of a message to get across, they're kind of straightforward. They also go with lots of other clothes. Which is why whenever I spot one of these, I end up buying it.

That said, what in the world does "DMND" mean? I googled it and found that it is an abbreviation for a company called Digital Marketing Nanodegree. But it's also an abbreviation for a rock band, Diamond

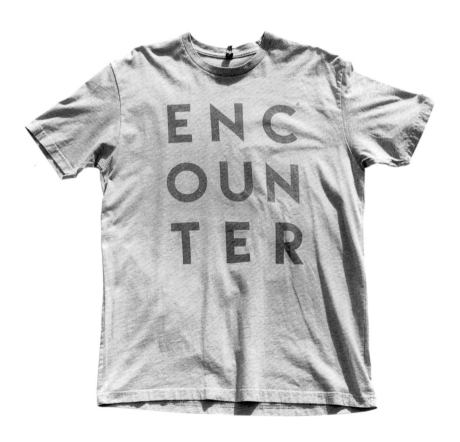

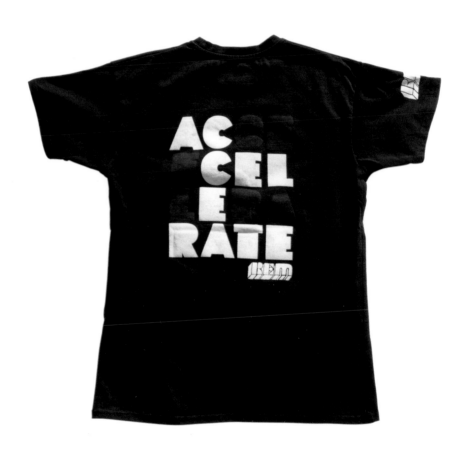

Youth. Or maybe it's just an abbreviation for the word *damned*. So I walk around town wearing this shirt with this big DMND on it, not knowing anything about it, unable to explain what it means. Sometimes I get a little anxious about it, wondering if it's okay to do this, but since no one's ever suddenly yelled at me or punched me, I figure I'm safe wearing it.

The shirt with ENCOUNTER on it is another one I can't figure out. I mean, I know the meaning of the English word, but I have no clue what this shirt was made for. Again, when I googled it, and found the name of a Japanese rock band (sure are a lot of rock bands in the world), as well as the name of an Italian restaurant in Shibuya in Tokyo. But it doesn't seem connected to either of these. I like the design, though, so I wear it a lot. I just hope it isn't advertising an online dating site or something.

ACCELERATE is from another rock band (again with the rock bands!), a promotional shirt from the band

R.E.M. Knowing this, I have no qualms about wearing it.

SQUAD is another riddle. "Squad," of course, could refer to a military squad, but which one? Every time I wear this, I pray that having this on won't lead to any harm being done.

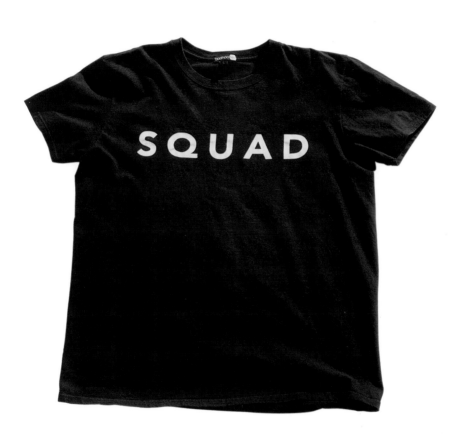

Springsteen and Brian

ABOUT THIRTY-FIVE YEARS AGO, I was on an elevator in a hotel in New Orleans, decked out in a "Jeff Beck Japan Tour" T-shirt, when a hefty older American man got on and turned to me.

"My son's Jeff Beck," he said.

"Pardon me?" I asked. For a moment, I had no clue what he was trying to tell me.

"What I mean is, I'm John Beck, and my son's Jeffrey Beck. We call him Jeff."

"But no relation to the guitarist?"

"Nope, none. The name's just the same, that's all."

Okay—how was I supposed to react to that? Where do you go from there in the conversation? It wasn't like I could ask something like, "So—how's your son doing?" I'd never met the guy. As we got off the elevator and walked along, the silence was deafening.

People tend to buy T-shirts when they go to concerts. If the concert's enjoyable, it makes a nice keepsake . . . Though you may never actually wear it, and it ends up just that—an unused keepsake.

I bought the "Springsteen on Broadway" T-shirt in October 2018. Usually, the only opportunity to hear Bruce Springsteen live is at massive venues like, in Japan, the Budokan or the Tokyo Dome. But this time he was appearing at the Walter Kerr Theatre on Broadway, which seats under a thousand. As a result, the concert was tremendously popular, selling out right away. Still, I managed to score a ticket through some connections I had. The performance was amazing— Bruce was right there, only twenty or twenty-five feet away, as if he didn't need any sound system at all. The

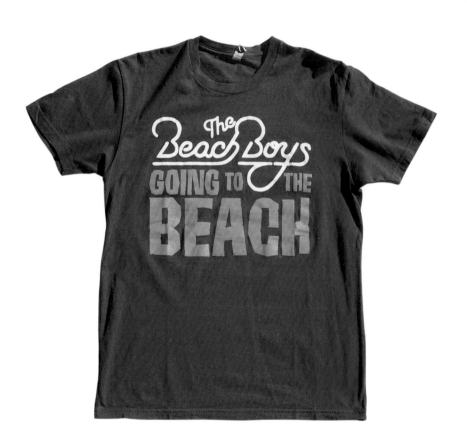

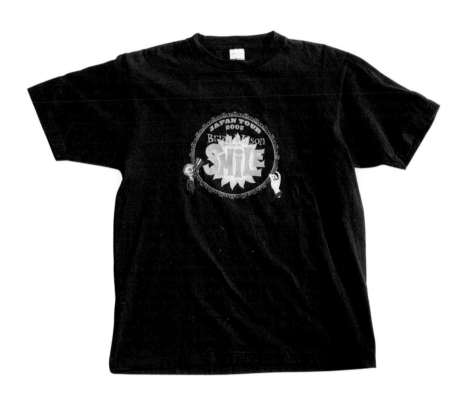

T

ticket cost me $850, but I figured it was a once-in-a-lifetime opportunity, so I went ahead and splurged. As you might guess, I bought a T-shirt too.

Springsteen is the same age I am. He has a firm, compact build and is incredibly energetic. And his voice is as strong as ever. A good lesson for me. I need to step it up a notch myself.

The Beach Boys T-shirt is one I bought as a memento at a concert in Honolulu a few years back. They were billed as the Beach Boys, but at that point it was basically just an old guys' band featuring Mike Love and Bruce Johnston, minus Brian Wilson. The Beach Boys and Hawaii seemed like the perfect pairing, but even so, the audience didn't really get into it. The shirt had a cool design, though, so I went ahead and bought it.

Compared to that, at the "Smile Tour" with Brian Wilson, the man himself, the audience was really fired up. Brian didn't have much of a voice anymore, and backup singers handled his trademark falsettos, but there was this intensity running through the audi-

ence like, *Hey—we're actually hearing Brian Wilson singing "Surf's Up" live!* Made me realize how big a role charisma plays in music.

The R.E.M. shirt is something I just threw in, since I really like that album.

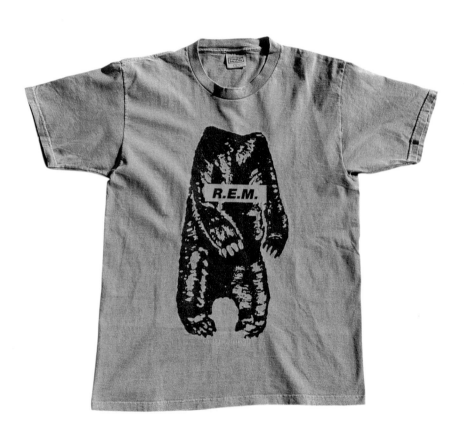

Car Wash

1

2

3

4

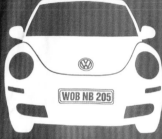

WOB NB 205

New Beetle
Volkswagen

Volkswagen's Quite Amazing

T-SHIRTS HAVE ALL KINDS OF DESIGNS, but you've got to be braver than one might think to wear shirts with car-related themes.

Take T-shirts with Ferrari or Lamborghini designs. Your everyday person, with ordinary social sense, wouldn't be able to pull these off, now, would he? An eccentric individual like Quentin Tarantino might, but the average person would be labeled a *brat* of the highest order.

Putting aside these *supercars*, even with shirts with Mercedes, BMW, or Porsche designs, you need some

kind of gimmick for them to work. Otherwise they come off like some well-heeled guy loudly ordering the most expensive, exclusive items at an unagi restaurant. All of which isn't going to win you any points with anyone. Best to forget it.

That said, if you ask people if they're hoping instead to wear a Suzuki Hustler or Toyota Prius T-shirt, I kind of doubt they'd want to. At least, that's true for me. Though I haven't actually seen a T-shirt along those lines, so I can't say with 100 percent certainty that I wouldn't do it. But let's face it—the chances are slim.

So as I pondered this question, arms folded, lost in thought, I arrived at this conclusion: A Volkswagen T-shirt would be just right. Strangely enough, Volkswagen fits that position—if you'll pardon the expression—to a T.

Take this red New Beetle shirt. This is one I can really get behind. I wouldn't feel awkward wearing it

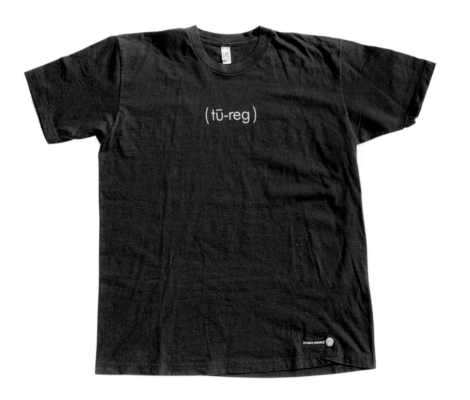

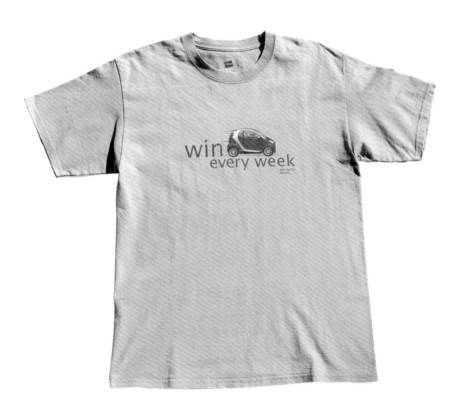

around town, but it also doesn't make you seem like you're putting on airs. A VW Beetle is definitely a middle-class car, but it doesn't feel shabby. Instead, the unspoken idea is that it's a kind of lifestyle choice.

Another Volkswagen T-shirt is for their SUV, the Touareg. This one, too, has simple lettering—in this case, telling how to pronounce the name. Kind of nicely nonchalant. The car itself shares a platform with the Porsche Cayenne, but doesn't try to (and doesn't) look high end, and that gives it a certain appeal. But that aside, Volkswagen seems to be making a real effort when it comes to T-shirts. I don't know about the future of automobiles, but from my view on the sidelines, I do hope that the T-shirt industry continues to do well.

The design for the German car brand Smart is also not so bad. This is one you could wear often. I'm not so sure, though, about what they mean by "win a car every week in August."

Moving on to a classic British-American car, this Shelby Cobra shirt is, well, a bit hit or miss. It's hard to say when I'd wear this one, but I could see it kind of working paired with a Comme des Garçons jacket — if you're hoping for a more punkish kind of look . . .

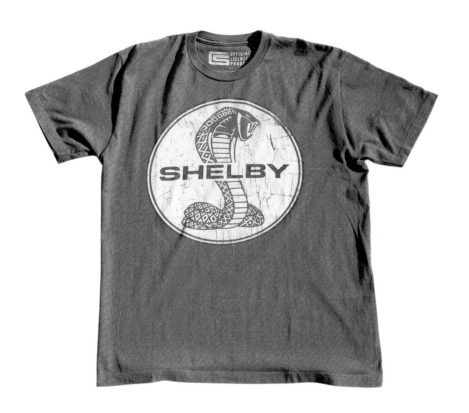

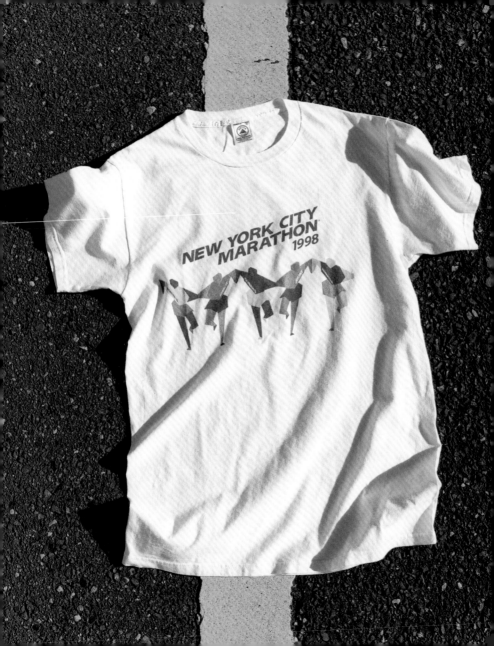

Can't Help Thinking
About a Nice Cold Beer

SOON AFTER I became a full-time writer, I started running. You get out of shape sitting at a desk every day, so I decided I had to start exercising, and made up my mind to start jogging around the neighborhood. Before long, I was totally into running, and began actively seeking out races. In the nearly forty years since, I've run at least one full marathon every year.

Not just full marathons, but half marathons and ten-kilometer runs, too—even a one-hundred-kilometer ultramarathon and the occasional triathlon. So the T-shirts you get after completing a race have piled up

T

38

around my house. They're nice mementos, so I keep them and store them in cardboard boxes—though I don't normally wear them around, and they do take up a lot of space.

I picked out four running T-shirts to include from that large pile.

The shirt with the five runners holding hands is from the 1998 New York City Marathon, and represents how the course runs through the five boroughs of the city. This course is a fascinating one to run. It took me through some spots that I wouldn't usually see: a neighborhood that's 100 percent Orthodox Jews, an area that's all Brazilians, another place where it's all Africans. My two legs took me through this variety of neighborhoods in the city, and it was an amazing experience. In my humble opinion, if you want to really know this massive metropolis, nothing beats running the NYC Marathon.

It's a tough race, though, for runners, since you have to cross several bridges along the way. The middle of

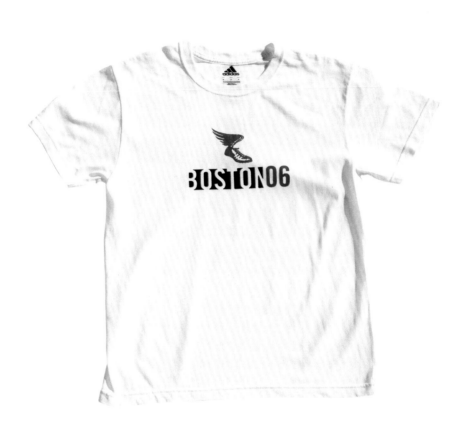

suspension bridges is very high, and it uses up a lot of energy to go up the hill and then back down. The last part of the race takes you through Central Park, where there are plenty of hills, too, and by then, frankly, I was worn out. Still, though, my personal best in a marathon was in New York in 1991.

In 1998, I also ran the Murakami Triathlon. I guess I had a lot of energy back then. When I wear this T-shirt abroad people ask, "So, Mr. Murakami, you're sponsoring a marathon now?" But of course that's not the case. Murakami City in Niigata Prefecture sponsors the race, and I just happened to take part. There's no connection with me or my family at all. I like this race a lot, and have run it five or six times. Afterward I always celebrate with a few cups of the well-known local sake, Shimeharitsuru.

The next T-shirt is from the 2006 Boston Marathon. The Boston Marathon is my very favorite full marathon. The views along the course are wonderful, and the crowds along the way are so great about cheer-

ing on runners. No other race gives me the same feeling of how wonderful a *tradition* can be. After the race I always head over to Legal Sea Foods and enjoy the locally caught cherrystone clams, washing them down with Samuel Adams on tap. As I near the end of the race, this scene always comes to mind, and thinking about how great it will all taste helps me make that final push. At that point it's hard to stop fantasizing about a nice cold beer.

The last T-shirt is from the Great Aloha Run in Hawaii, a race that is really popular among the locals on Oahu. It's a thirteen-mile course starting at the Aloha Tower and ending up at Aloha Stadium. In 2006, Louis Vuitton sponsored the race. Not to imply that we received Louis Vuitton shirts. It's just an ordinary T-shirt with their name plastered on it. But still, it might be fun to wear it in town and think, like, "Hey, check it out, y'all. It's a Louis Vuitton!" Maybe . . .

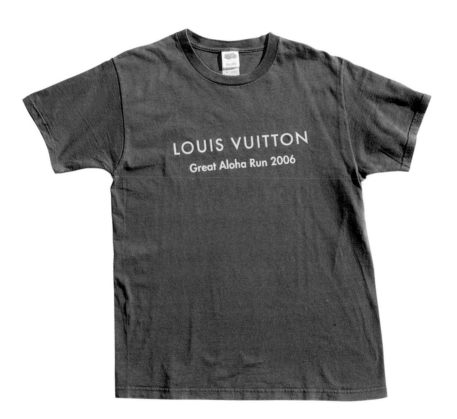

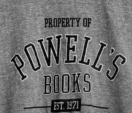

A Book, Anyone?

IN JAPAN we have the phrase *dokusho no aki,* meaning "Autumn is the best season for reading," but leisurely reading in the shade on a bright, sunny summer afternoon isn't bad either. Autumn isn't at all the only season for reading. People who love reading are going to read no matter what—whether it's snowing or the summer cicadas are screeching outside, or even if the police command them, "Don't read!" (Check out *Fahrenheit 451.*) Conversely, the people who don't read won't do it no matter what, so it doesn't really matter about the season . . .

With that in mind, I've also gathered T-shirts that relate to reading. This is just a sample of the many I have at home.

The largest photo is of a T-shirt from the famous Powell's Books in Portland, Oregon. I went there once and their atmosphere and fantastic collection of books make it an amazing independent bookstore. It's in a huge building, sort of like a warehouse, and you can easily spend a whole day there. I'd love to have a bookstore like that in my neighborhood.

When I visited, I picked out a few interesting-looking books and the woman at the register asked, "Are you by any chance Haruki Murakami?" When I told her I was, she said, "Great!" and had me sign a few dozen books. Not exactly what I'd planned—an impromptu signing event. As I recall, this T-shirt is the one they gave me as a memento. Well, if I can be useful to a bookstore, I'm glad to help out.

Now that I think of it, though, I've spent a lot of time at the Kinokuniya bookstore in Shinjuku, but no

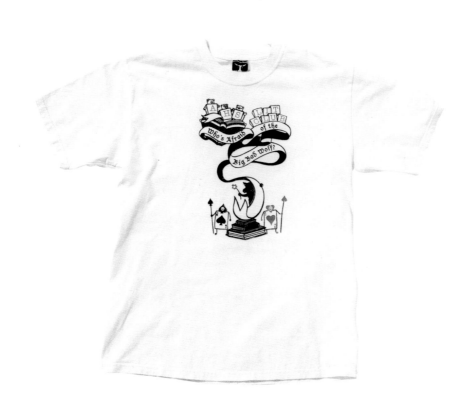

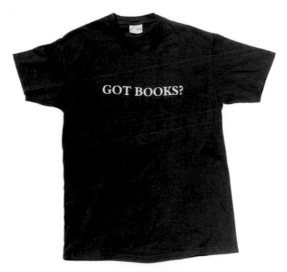

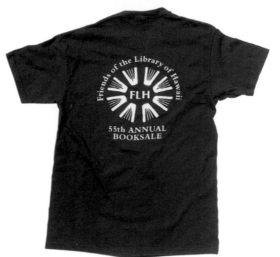

T
44
front
back

one's ever spoken to me—either in the store or at the register. I wonder why (not that I'm complaining—I much prefer it that way).

The next T-shirt is from the AHS Literary Club. I bought this for two dollars at a thrift shop, so I don't know how this club started (I wonder about it sometimes . . .) or any details at all. But the WHO'S AFRAID OF THE BIG BAD WOLF text, the playing card soldiers, and the three little pigs and the wolf holding a flower all point to the fact that the club must have something to do with children's literature. It's a very nice design, and I'm personally quite fond of it. The wolf doesn't seem so scary, but maybe that's just appearances. I mean, he *is* a wolf, so you'd better watch out.

The next is a T-shirt from the Honolulu Library's annual book sale. Many libraries in America have annual sales to get rid of the books that they don't need anymore. Prices are low, and there are some real finds. If you're a book lover, it's like you've died and gone to heaven. Whenever I have the chance, I

always take a peek to see what I can find. I imagine this T-shirt was one given out to the volunteers who helped out at the sale.

How about the "Got Books?" shirt? In the midst of all your busy days, please try to carve out some time to curl up with a good book. If people don't buy books, then we authors can't make a living, after all. This one, too, I bought at a thrift shop in Honolulu.

The last T-shirt is from a famous independent bookstore in Seattle, the Elliott Bay Book Company. I got it when I gave a reading there many years ago. A fantastic bookstore.

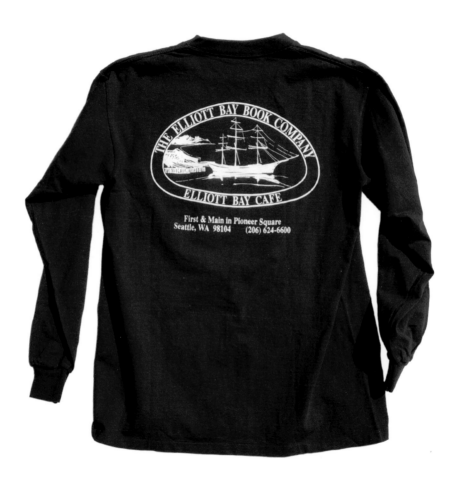

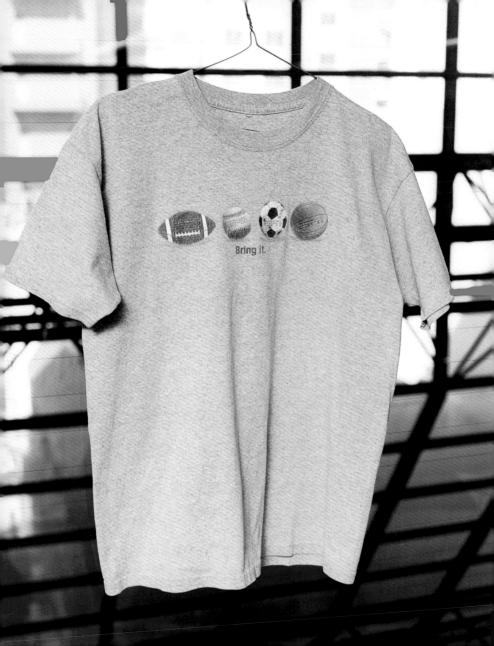

The Sandwich Man

BACK WHEN I WAS A BOY, there were people whose job was to be the "Sandwich Man," and wear large boards over their front and back, and walk the streets. They were like a walking billboard. This was back in the 1950s. TV wasn't so common back then, and of course social networking was still far in the future. The media's coverage was sparse. There was a popular song, too, titled "The Town's Sandwich Man," that went "Us guys are the Sandwich Men . . ." By the 1960s, TV was everywhere and the job of Sand-

wich Men vanished from the world. Kind of sad, really . . .

Nowadays you might say that the spirit of the Sandwich Man lives on in promotional T-shirts. Companies slap their logos on T-shirts and distribute them. And people wear them and walk around town. For the companies, it's free advertising. It's pretty inexpensive if you produce a lot of them, and an easy way to have your advertising expenses pay off.

Which is why, when you walk around town, you see "volunteer sandwich men" all over the place.

The gray shirt in the large photo is a promotional T-shirt made by ESPN, the sports channel. The design shows the four pillars of sports—football, baseball, soccer, and basketball. Direct and nicely done. Of the four, my favorite's baseball. Go Yakult Swallows! Oh—am I wandering a bit?

The red shirt is from the British economics magazine *The Economist*, with the message THINK RESPONSIBLY. A very stylish message, as you might expect of

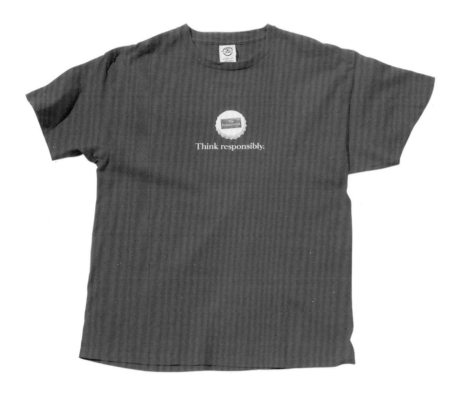

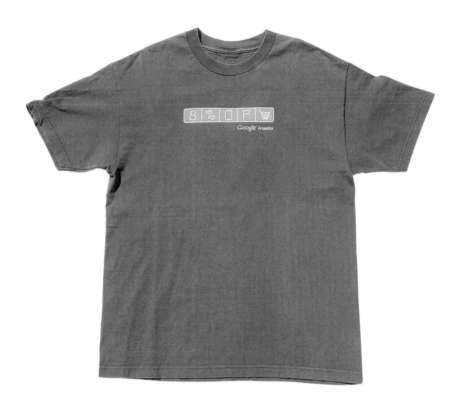

something British, but it's still a T-shirt and it makes me wonder about how to react to such a sudden, challenging dictum. The message, of course, also reminds you of the "Drink Responsibly" slogan you see in alcohol ads.

The brown T-shirt has a row of icons, with the words GOOGLE ANALYTICS written below. This is a field that's way over my head. (Ask me about used-record stores, though, and I'm all over it.) Google Analytics would be an analytic tool used by Google, right? I looked it up online, and it said it's a "predictive analytic algorithm that utilizes built-in statistical analysis functions and Adobe Sensei machine learning . . ." You lost me at *predictive*. I don't get it, but I still wear the T-shirt. The T-shirt's not to blame.

The next shirt is from Olympus. I bought this one, too, at a thrift store in the U.S. for a couple of dollars. On the back is a detailed schematic for the company's IC recorder. This kind of old-school T-shirt from the

manufacturing industry is simpler, easier to grasp, and makes "us guys" breathe a small sigh of relief.

So that's how us guys—including me—are like Sandwich Men walking the streets day to day. How about you?

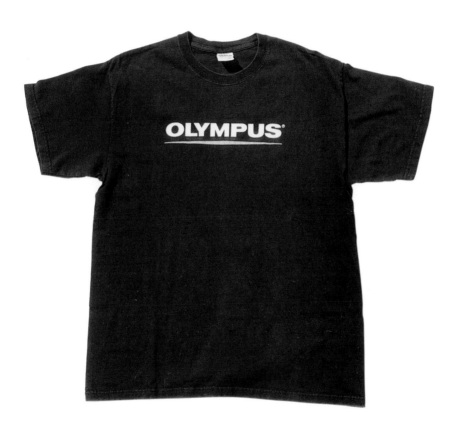

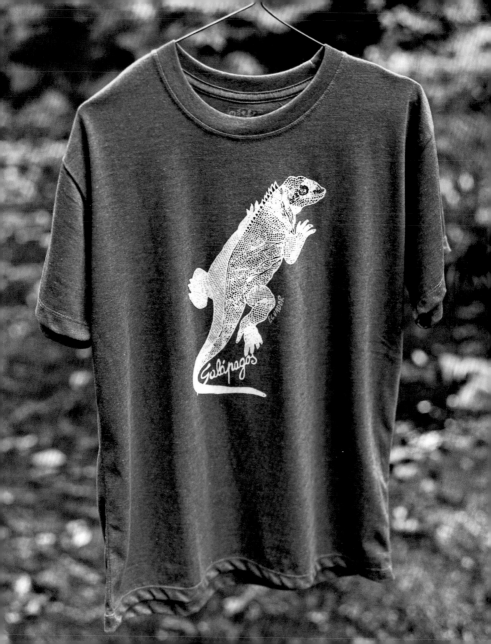

Lizards and Turtles

I'M NOT PARTICULARLY FOND of lizards, but the other day when I was straightening up the T-shirts in my drawers, for some reason a bunch of shirts with lizard designs slithered out, and I've lined them up here. I had space for one more, so I added a shirt with a turtle on it, but that's totally coincidental. I'm not arguing that turtles are the same species as lizards. Don't get me wrong.

I call them all lizards, though the three shown here are all different types. The first one is an iguana from the Galápagos Islands. The second is a Hawaiian

T

gecko. The third one? I'm not at all sure. I'm afraid I don't know much when it comes to varieties of lizards.

When I visited the Melbourne Zoo, they had me pet a huge lizard. "Don't worry," they assured me. "It won't bite, so go ahead and pet it." Can't say I was very excited about it, but I couldn't just reject their kindness out of hand. I petted its head a little, like petting a cat. It was a rare type of lizard covered in scales, found only in Australia, and its skin felt kind of weird—all hard and dry.

For lizard lovers, this would have been an unbelievably amazing experience, but that's just not my thing, so I reluctantly petted the lizard's head, all the while thinking I'd much prefer to be petting a cat. The lizard, too, seemed to grudgingly allow me to touch it. *Not much I can do about it* seemed to be its attitude about the whole thing.

I visited the Galápagos once and found there were iguanas literally all over the place. At first it was like, "Look! Iguanas!" and I was astonished, but soon it was

more like "What? More iguanas!" Even if it were pandas, if a place were covered with them as far as the eye could see, you'd end up having the same reaction: Pandas? *Again?*

In the Galápagos there's an unusual variety of iguana that dives under the ocean to eat algae. These guys can hold their breath for an hour while they're underwater. Apparently they can lower their body temperature and stop the blood flow in their bodies, which makes it possible for them to stay under the water for so long. Most iguanas are vegetarians, but there aren't any plants growing on the island they live on, so they adapted to their environment and evolved this way. Darwin studied these marine iguanas and used them as an example in his theory of evolution.

Darwin was also the one who demonstrated that these fellows could stay underwater for an hour. He placed an iguana underwater, increasing the interval by ten minutes each time, and only when he got to seventy minutes did the iguana die, proving they could

stay underwater for sixty minutes. But think about that poor iguana, forced to be submerged for seventy minutes. Science can certainly be a cruel pursuit at times.

All of which is to say that I bought this iguana T-shirt at the airport souvenir shop in the Galápagos, as a way of paying my respects to that poor iguana Darwin forced to stay underwater until he drowned.

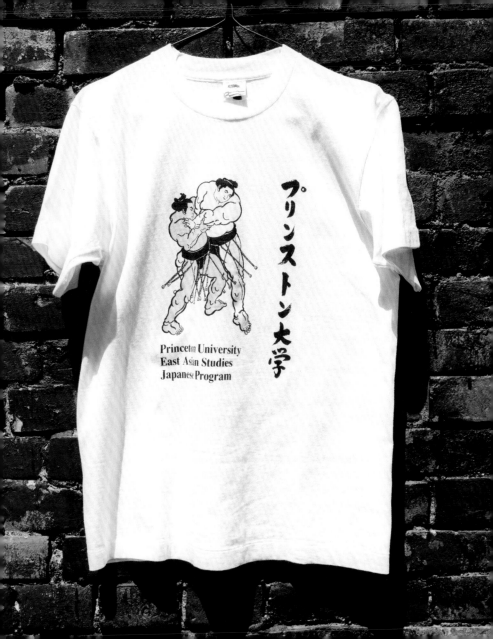

プリンストン大学

Princeton University
East Asian Studies
Japanese Program

College T-shirts

THESE DAYS I hear the term *antisocial forces* a lot, but I wonder who was the first to use it, and when. If a yakuza gang member threatened you saying, "I'm inna gang . . ." you'd more than flinch, but if he said, "I'm a member of an antisocial force," it really wouldn't hit you, would it? "Oh, is that right?" is about all you'd say. I can't believe, though, that they made up this term with this in mind.

And what's the opposite of *antisocial forces*, anyway? I thought about it a lot, but couldn't come up with the right term. *Pro-social forces?* But if everyone who

endorsed societal norms joined together to create one larger force, it could be problematic. Might be preferable to have all those yakuza . . . no, I'm not going to go that far.

Okay, putting all that aside, here we have T-shirts with the names of colleges on them.

The largest photo is of a T-shirt designed by the Japanese Program of the Department of East Asian Studies at Princeton University. I was on the faculty of Princeton for about two years, and during that time they said, "Here you go, Mr. Murakami," and handed me one of these. Truthfully, though, I didn't have much opportunity to wear it. It's not a bad design, but unless you get yourself all fired up about it, it's not exactly the kind of thing that would work when I'm strolling about town. Though I do treasure it as a nice memento.

The next T-shirt commemorates the 2016 graduation ceremony at Yale University. I was invited to the graduation that year to be given an honorary doctorate. Pretty cool, huh? But there's nothing particularly

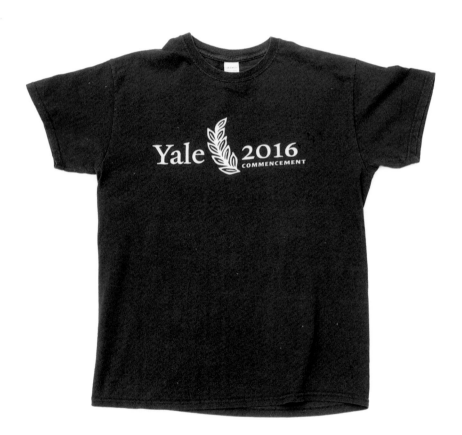

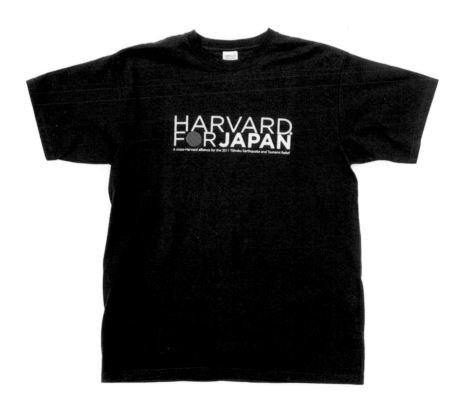

good connected with an honorary doctorate. No prize money, no special privileges. All you get is a flimsy little diploma.

But there are usually several people receiving honorary doctorates at the same time, so you can meet all kinds of very interesting people. At Yale I was seated next to Alice Waters, the charismatic chef and owner of Chez Panisse, and heard some amazing stories. When I received an honorary doctorate from Princeton I was seated beside Quincy Jones, and we chatted about jazz all during the graduation ceremony. He proudly told me, "I produced Seiko Matsuda's album." I'm sure he has many other things he could be proud of.

The next shirt was made to support relief efforts after the 2011 Tohoku earthquake and tsunami. The tiny writing below is hard to read, but it says, A CROSS-HARVARD ALLIANCE FOR THE 2011 TOHOKU EARTH-QUAKE AND TSUNAMI RELIEF. American universities are generally very open to helping out with various social issues and problems, and this kind of organized

movement sprang up quickly and spontaneously. I wish Japanese universities could learn a lesson from this. *Pro-social forces* like this are, needless to say, very desirable.

And then there's the shirt from a university in Iceland. When I attended the Reykjavik International Literary Festival, I spoke at this university. Iceland's total population is only 350,000, of which ten thousand are students at this university. A pretty amazing percentage of the population. Iceland's a fascinating country. I got to see the aurora borealis there, and I hope to return there someday.

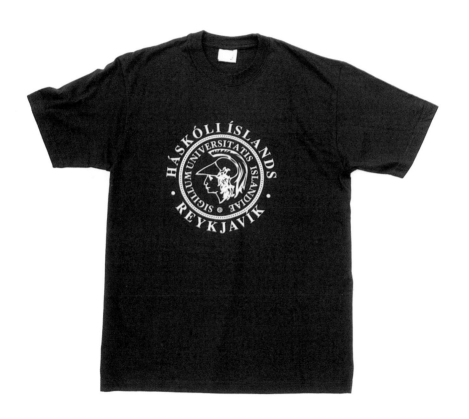

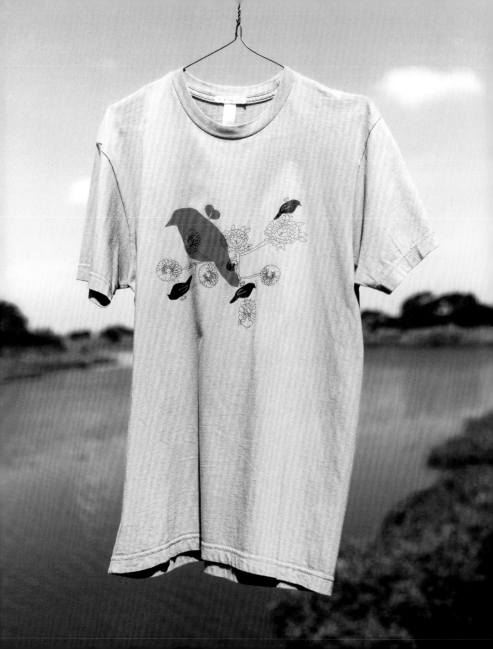

Soaring Through the Air

I'M PRETTY FOND of swimming. That includes swimming for a long time without any particular goal. I used to compete in triathlons, so I'd train to swim freestyle for 1.5 kilometers at my own pace. Though not exactly a *runner's high*, I do reach a similar high while swimming, and when I swim for a long time, I start to feel really good. I even feel like singing. ("Yellow Submarine" is a favorite. *Glub glub.*) At times like those I think, "You know, swimming must be the next best thing to flying through the air."

Mention this to anyone, though, and they usually

shoot back with, "So, Mr. Murakami, have you ever flown through the air?" Well, if you put it like that, no, I can't say that I have . . . I just imagine it must feel like that. The birds might laugh at me.

So this collection is a special bird-themed edition. It's not like I consciously collect T-shirts with bird designs, but somehow I've acquired a flock of them.

The first shirt here is a *Wind-up Bird Chronicle* shirt sent to me by a reader in the U.S. who was inspired to create this after reading the novel. I think it's a cool-looking shirt. A very smart design, and I bet if they marketed it, you could really find an audience for it. I like this one, and actually wear it pretty often.

The brown T-shirt features a pelican (at least I believe that's what it is). When I visited the Galápagos Islands not long ago, the place was crawling with pelicans. I'm sorry to say this, but there were so many of them that it didn't feel much different from seeing the throngs of pigeons that populate my neighborhood park.

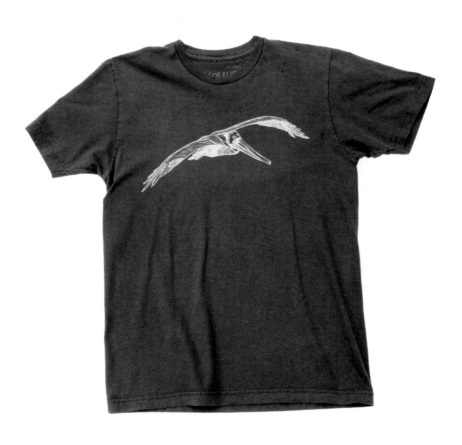

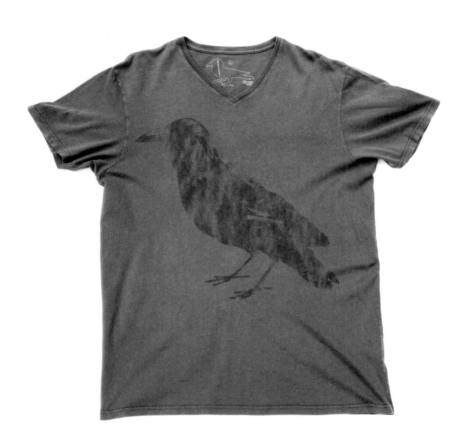

The green T-shirt shows a picture of a crow (again, I think that's what it is). I've had some terrible experiences with crows. When I run in the morning, they often attack me. Especially when I take the road that cuts through Aoyama Cemetery, they'll swoop down low and either threaten me or actually get their claws into my head. I don't recall ever doing anything bad to crows, and have never felt like doing them any harm, so I'm astonished and dumbfounded that they would tear into me like that. But I guess crows have their own crowish logic. Or maybe some literary critic has been reincarnated as a fierce, violent crow . . . I'm kidding, of course.

The last shirt features what I suppose is a seagull. As you've gathered, I'm not very clear on species of birds, so I'm sorry, but *suppose* is as close as I can come. Back when I lived on an island in Greece, there was one particular seagull who was very friendly and would play with people. But it would occasionally peck at me with its beak, and boy, did that hurt. My advice? Don't play

with seagulls. They are pretty fierce when they want to be.

What kind of place is the East Dock Bar N Grill, I wonder? I don't know where it is, but someday I'd like to stop by and check it out.

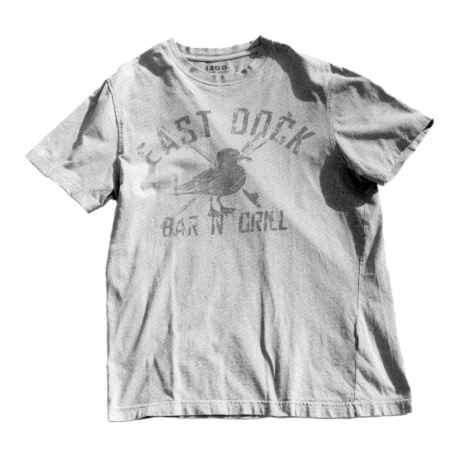

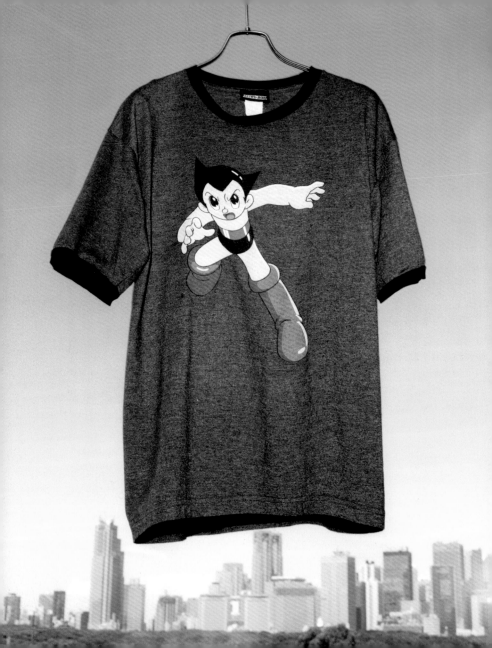

Superheroes

THESE DAYS, whenever I feel like going to see a movie, all the films showing in the cinema complex near me are based on Marvel Comics. *What's up with that?* I often ask myself. I guess there must be a demand for it if they're making one after another. But does the world really have such a desperate need for so many superheroes?

Back when I was a boy—we're talking ancient history here—I often watched *Superman* and *Batman* on TV. *Batman* in particular was designed to be playful and showed all the *crash-bang* sounds on the screen

in huge letters, like "BAOOOOOM!" It was fun in a silly, absurd way. The recent *Batman* movie series, though, is very real, and quite dark. At first I thought, *Hey, that's kind of refreshing*, but gradually I began to find them exhausting.

The Tetsuwan (Iron Arm) Atom T-shirt is one I picked up very cheaply at the student coop store at Harvard. A Tetsuwan Atom T-shirt in the bargain bin at the Harvard coop? Kind of inexplicable. It seemed so totally out of place that I couldn't help but buy it. Tetsuwan Atom is shown on American TV under the name Astro Boy and has become pretty popular. They use the same opening theme song, too, as in Japan, translated and dubbed into English. (The English version's pretty cool.) But I wouldn't want them to make a live-action movie of Tetsuwan Atom showing his darker side. Though maybe they already have, unbeknownst to me . . .

The Superman and Batman logos are instantly rec-

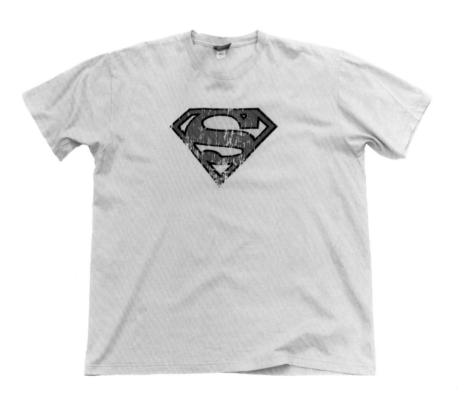

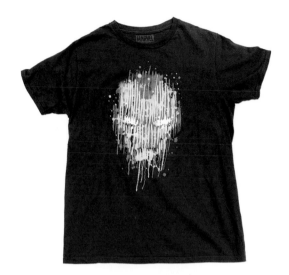

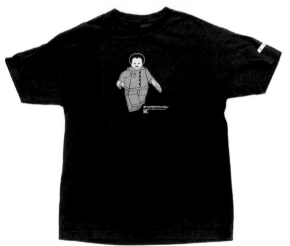

ognizable, universal classics. A little too recognizable for there ever to be a situation when I'd wear one.

This next shirt depicts—I'm guessing here—Iron Man. But the face is so artistically distorted that I'm not totally sure. The label inside says MARVEL COMICS, so it's got to be connected. A striking design, though, whatever it is.

The final T-shirt shows some unknown old guy on it. I bought it in a comic-book shop, so I'm supposing it's a character from a comic, though by the look of him, I'd say he's less a hero than an antihero. Like Dr. No.

As I was straightening up all my T-shirts, a thought struck me: There are no superheroes who actually appear in our world, so maybe having this flood of superhero movies isn't such a bad thing after all.

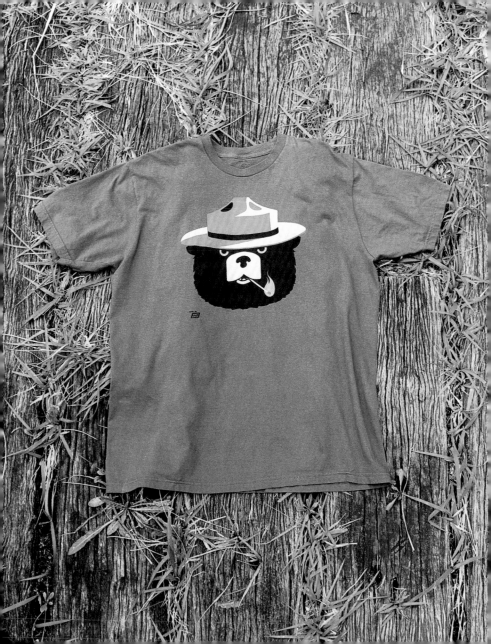

Setting Free the Bear Ts

AS I WAS ORGANIZING the T-shirts in my drawers, I
noticed a lot with bear designs, so I decided to gather
them together. It's not that I'm particularly fond of
bears, but I just happened to collect a lot of bear
shirts.

The large photo is a parody of Smokey the Bear.
In 1944, Smokey the Bear was designated by the U.S.
government as an official symbol for a forest fire pre-
vention program. The slogan was, of course, "Only
You Can Prevent Forest Fires!" This was during the

Second World War, and the Japanese military had a plan to send incendiary balloons across the Pacific to start forest fires along the West Coast. Smokey appeared as part of the American government's plan to deal with the potential consequences. So he was designed to be a bear who had a positive role to play in society.

The Smokey on this T-shirt, though, seems threatening. There's a sinister look in his eyes, and he's got a lit match dangling from his lips. An antisocial, delinquent version of Smokey. In any event, let's remember not to start any forest fires. Once, when we were driving in Australia, we were surrounded by a forest fire, and believe me it was terrifying. The Japanese military's balloon strategy didn't work, but with all the drones buzzing around these days, I'm a little anxious that it could develop into a real threat.

The next shirt is from the Ventura Surf Shop. They use a bear because it's the state animal of California.

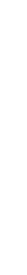

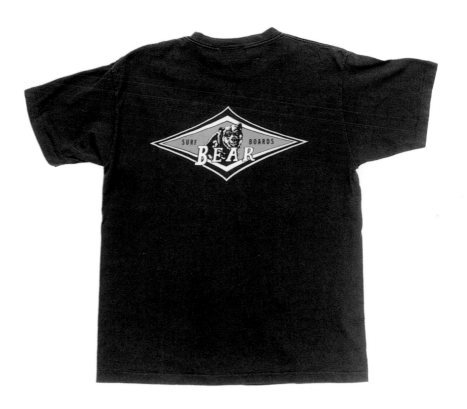

California and bears don't really go together in my mind, but there you are . . . Maybe there were lots of bears roaming around the state in the past? Ventura County, where this shop is located, is an affluent residential area near Santa Barbara, and a surfing mecca. The writing on the T-shirt says LIFE'S BETTER IN VENTURA, CA. I haven't been there yet, but according to an informational pamphlet I read it sounds pretty nice—warm year-round, with little rain, and lots of gorgeous beaches. But will going there really improve your life? That much, I can't say.

The next shirt is from a surf shop called Bear Surfboards. The thing is, it's actually an imaginary surf shop that appears in John Milius's film *Big Wednesday*, and doesn't really exist (as far as I know). But it's a great design, and became pretty popular for a time. That's when I bought this shirt. *Big Wednesday* was a fun movie, very entertaining.

The final shirt is from the surfing brand Hur-

ley, but what kind of creature is this camouflaged, unknown animal, anyway? It sort of looks like a cat, but there's a bit of rabbit in it, too. I'm stumped, but I went ahead and slipped it in with the other bear-related shirts.

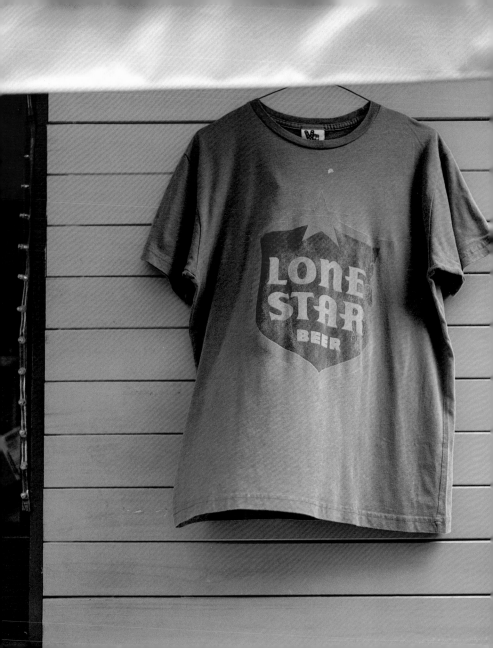

Beer Ts

I STILL HAVE A TON of shirts I could bring out, but if I did, this book would never end, so I'll wrap things up here. The final group of T-shirts are all, as you might expect, related to beer. T-shirts remind us of summer, and summer reminds us of—you got it: beer. But beer isn't just for summer, of course. You can be very happy sitting in front of a roaring fire, in a comfortable rocking chair, a cat in your lap as you stroke its head, sipping a cold beer—it doesn't get much better than that.

T

Excuse me? You don't have a fireplace, or a rocking chair, or a cat? I'm sorry to hear that. Come to think of it, I don't either. Not even a cat. I was just imagining the scene and how wonderful that would be. It's good to have a lively imagination, right?

The large photo is of Lone Star, a beer from Texas. I rarely see it in Japan. The Lone Star, of course, is the symbol of Texas, the Lone Star State. Have I ever drunk a Lone Star beer? I haven't. I wonder what it tastes like.

The next shirt is from Heineken. This one's a much more famous brand, of course, a Dutch beer that everyone knows. I drink Heineken a lot whenever I go to the U.S. In crowded, noisy bars, you have to shout out your order to the bartender, and I've found through experience that the one brand I can pronounce so that it gets through to them is Heineken. I've tried ordering Miller or Samuel Adams, but it never works. Worst case, they bring me a rum and Coke.

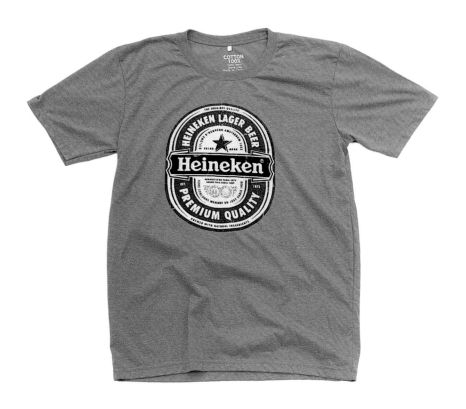

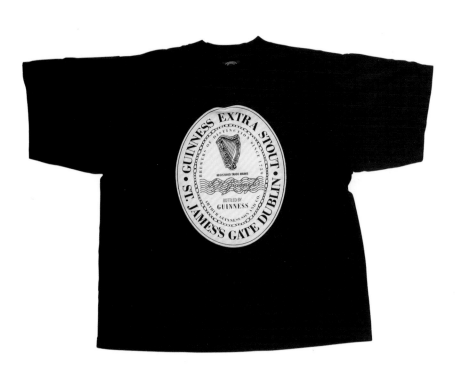

The next shirt is of Guinness, the famous Irish stout. Have you ever tried a Guinness in its homeland? Talk about tasty. When I traveled around Ireland, I'd stop in local pubs along the way to enjoy a Guinness. I found that the temperature of the beer, and the amount of foam in each glass, was different in every pub and every town—not one beer tasted exactly the same. I found this interesting, so I continued to order Guinness in all kinds of towns . . . Whoa, as I write this I find myself dying for a Guinness. There's an Irish pub in my neighborhood, and their mulligan stew is . . . No, I'd better finish writing this first.

The last one is Blue Heron Pale Ale, a beer from Portland, Oregon. Portland is a beer mecca, and there are lots of microbreweries and all kinds of local brews. The beer industry thrives in part because high-quality hops grow in the nearby Willamette Valley. When I visited Portland, I drank a lot of beer. The blue heron,

by the way, is the official city bird of Portland. Did you know that? Who would, anyway?

Okay, the obvious question is whether I ever tried Blue Heron Pale Ale. You know, I can't remember. I think I may have been a bit tipsy during my visit.

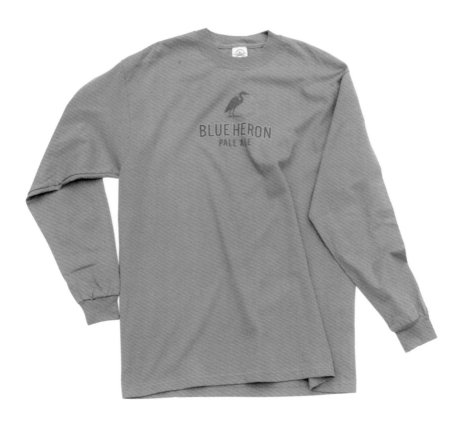

All the T-shirts I Ended Up Collecting, and the Ones That Weren't Included in the Above Essays

(INTERVIEWER: KUNICHI NOMURA, WRITER AND INTERIOR DESIGNER)

(THIS INTERVIEW WAS PUBLISHED IN THE AUGUST 2018 ISSUE OF THE MAGAZINE *POPEYE*.)

HOW DID YOU FIRST START WEARING T-SHIRTS?

I started wearing them a long time ago, but back when I was a teenager, wearing T-shirts in Japan wasn't a thing yet. Back then all we had were undershirts, or T-shirts as underwear, and none of them had logos or designs. I think illustrated T-shirts started to appear in Japan in the 1970s. I recall that T-shirts from UCLA and from

Ivy League universities were popular, as were shirts from the Yankees and other sports teams. I think those kind of shirts have been around for quite some time. You remember VAN jackets? T-shirts with their logo were popular, too. The Ivy League look was about all they had, so of course I wore those, too. I think as the '70s rolled on more kinds of T-shirts started to appear. There were shirts with rock band logos—T. Rex was one—and giveaway promotional T-shirts. Novelty T-shirts, you'd call them. T-shirts had become everyday wear by the time I started writing novels in 1978–79. And T-shirt culture really spread around the time the magazines *Made in USA Catalogue* and *Popeye* were first published, which was around the mid-'70s, as I recall.

DID YOU READ *POPEYE* YOURSELF, MR. MURAKAMI?
I did. I was still running a jazz cafe and bar, and I would buy magazines for the customers to read. The special editions devoted to U.S. products were amazingly popular. I remember the pages would fall apart after so

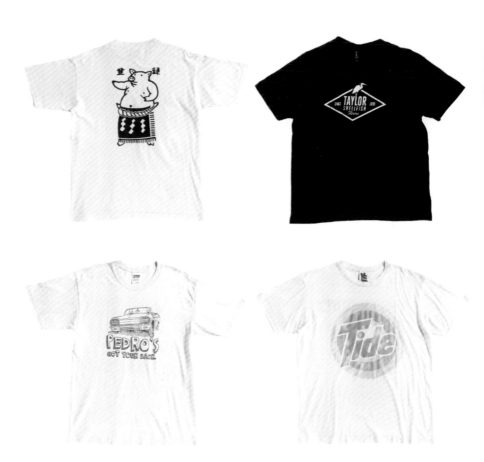

T

74 TOP LEFT: A shirt from a shop in Yabaton, a restaurant featuring the famous cuisine of Nagoya, *misokatsu—tonkatsu* flavored with miso

75 TOP RIGHT: A Taylor Shellfish Farms shirt I bought in Seattle

76 BOTTOM LEFT: The car in the shirt has a license plate that says VOTE, so I'm guessing this is related to an election?

77 BOTTOM RIGHT: A Tide detergent shirt. I like the way the color has faded.

many people flipped through them. I think it was after this that I started buying T-shirts at rock concerts.

WHICH CONCERT T-SHIRTS DID YOU BUY?
I don't recall my first rock T-shirt. But I do remember buying a Jeff Beck shirt [*laughs*]. I don't have it anymore, though. T-shirts are consumable goods, and they wear out. I should have saved them. There aren't many jazz-related T-shirts out there, so I don't have any.

I'D LIKE TO TALK ABOUT SOME OF THE SHIRTS THAT YOU ALLOWED US TO PHOTOGRAPH. WHICH ONE OF THESE IS THE OLDEST, DO YOU THINK?
I think the oldest is the shirt from the 1983 Honolulu Marathon. This appeared in a book entitled *Suterarenai T-shirts* (T-shirts I Just Can't Part With) by Kyoji Tsuzuki.

I SEE. THERE ARE ALL KINDS OF T-SHIRTS PICTURED HERE IN THIS BOOK, BUT I GET THE FEELING YOU HAVE SOME CRITERIA FOR WHICH ONES YOU ACTUALLY BUY.
I don't much like going to a store and buying some

chic T-shirt. I prefer getting novelty shirts, or finding shirts in a thrift shop. So I have almost no brand-name T-shirts. I love spending hours rummaging around at Goodwill. I guess I've got a lot of time on my hands [*laughs*].

DO YOU HAVE SOME SORT OF GUIDELINE YOU FOLLOW, LIKE WHEN YOU BUY USED RECORDS?

First I contemplate the design, and then the genre. I've bought a lot of T-shirts with a record player or record design on them, because I love that genre [*laughs*]. There are several like that here. I like shirts related to beer, cars, and advertising. I have all kinds of ESPN and Coors shirts. I really like the Olympus shirt too.

YOU TAUGHT JAPANESE LITERATURE IN THE U.S., SO I IMAGINE YOU HAVE A LOT OF COLLEGE SHIRTS, INCLUDING THOSE FROM IVY LEAGUE SCHOOLS.

I've bought a lot of college shirts when I visited campuses, but I find I can't wear them. It'd be a different story if I'd graduated from that school. It'd be a little

T

78 TOP: A novelty shirt from a Spartan race that Reebok sponsored
79 BOTTOM: One of the record-motif shirts I can't help but buy

T

Converse All Star, from my collection of company T-shirts

embarrassing to wear, say, a Harvard or a Yale shirt just because I happened to visit their campuses. That doesn't mean, though, that I wear a Waseda University shirt when I'm in Japan, even though it's my alma mater—I can't [*laughs*]. But shirts from lesser-known colleges, small liberal arts colleges off the beaten path—those I don't mind wearing. If I'm walking around wearing one of those and an actual graduate of the place sees me, I'm positive they'd stop and ask about it. So I wear them, but I do feel a bit nervous about it [*laughs*].

[*LAUGHS*] ALL THE SHIRTS YOU SHOW HERE HAVE DESIGNS ON THEM, BUT I RECALL YOU SAID YOU LIKE PLAIN SOLID-COLOR SHIRTS WITH NO DESIGN, TOO.

I mainly wear T-shirts with designs, but when I was in the U.S. and had my portrait taken by the photographer Elena Seibert, who specializes in author photos, I wore a T-shirt with a design on it and she said that wouldn't work, that you have to wear a solid-color shirt when

you're photographed. She showed me a photo of Truman Capote in a solid gray T-shirt, and said, "Pretty nice, huh?" and I had to agree [*laughs*]. Ever since then I always wear solid-color T- shirts to photo shoots.

I CAN SEE THE POINT. ARE YOU PARTICULAR ABOUT ANYTHING WHEN IT COMES TO SOLID-COLOR SHIRTS?

I like plain T-shirts where the neckline is a bit worn. It's kind of tricky to get it just right. Hanes and Fruit of the Loom shirts wear out just right, but this optimum condition doesn't last long. Solid-color T-shirts are consumable objects, and even if you kept them for a long time, they don't make mementos, really.

I SUPPOSE SO. THOUGH I THINK THERE MIGHT BE A LOT OF PEOPLE WHO FIND IT HARD TO GET RID OF THEM, AND THEY LET THEIR OLD T-SHIRTS PILE UP AT HOME, EVEN THOUGH THEY DON'T WEAR THEM ANYMORE. THEY DON'T WANT TO BE WASTEFUL. ARE T-SHIRTS STILL YOUR PREFERENCE?

In the summer I just wear T-shirts. Rarely anything else. The occasional aloha shirt, but basically a T-shirt

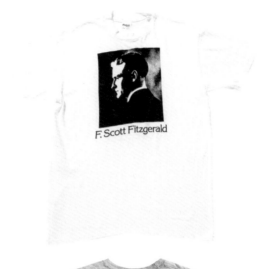

F. Scott Fitzgerald

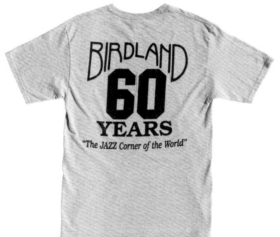

81 TOP: A portrait of F. Scott Fitzgerald
82 BOTTOM: A T-shirt from the New York jazz club Birdland, celebrating their sixtieth
 year in operation

and shorts. Actually, I've collected quite a few pairs of shorts as well [*laughs*].

SHORTS? WE MIGHT COME BACK WITH ANOTHER REQUEST SOMETIME.

I've got everything from cargo pants to shorts of all different lengths. So I wear shorts, a T-shirt, and sneakers with no socks. These days I've been wearing Skechers all the time since they're comfortable. When I go out, though, I make sure to take a bag with a pair of long pants I can put on over the shorts if need be, along with a regular shirt.

MEANING—?

Sometimes it's necessary. One summer I was invited by a publisher to eat at the sushi restaurant Kitcho in Ginza, and it wasn't until I arrived that I learned you couldn't wear shorts to dine there. It would have been awkward if I wasn't allowed to go in, seeing as how they'd gone to the trouble of inviting me [*laughs*]. "No problem," I said, and pulled out my long pants from

my bag and put them on right there at the front of the restaurant. Everybody turned kind of pale when I did it.

THAT'S NICE AND POLITE, BUT KIND OF WILD AT THE SAME TIME [*LAUGHS*]. I got the idea from the author Komimasa Tanaka. He's since passed away, but once, we were at a movie premiere, and he pulled a shirt and pair of long trousers from his bag and put them on at the front entrance. I thought, *What a great idea* [*laughs*].

TOKYO, MARCH 2020

TODAY WE'RE CONTINUING OUR EARLIER CONVERSATION, AND NOW THAT THE SERIES IN THE MAGAZINE HAS CONCLUDED, I'D LIKE TO GET MORE OF YOUR THOUGHTS ON THE SUBJECT. One thing I would like to say is this: I said that I bought a lot of these shirts for a dollar or $1.99 in Hawaii, right? Well, the prices have shot up all of a sudden.

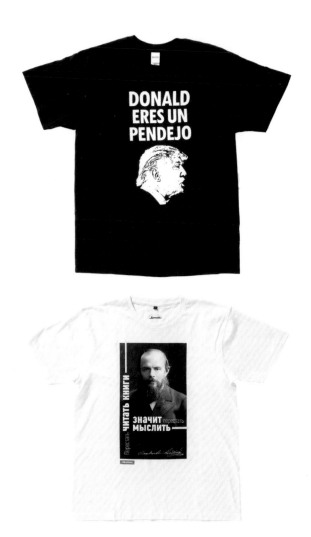

T

83 top: A Trump T-shirt made in Mexico I got from the author Paul Theroux. The Spanish means "Donald is an idiot."

84 bottom: I think it's Dostoyevsky, but I could be wrong.

Now the same shirts go for $3.99. I was wondering if this series had an impact.

MY APOLOGIES IF IT DID [*LAUGHS*].

If something's $1.99 I'll most likely buy it if I like it, but at $3.99 some of them will seem a bit overpriced. I just hope there aren't guys coming from Japan expressly to buy up armloads of these shirts.

THE JAPANESE CAN CERTAINLY GET A BIT FANATICAL ABOUT THINGS. RIGHT NOW, T-SHIRTS OF OLD BANDS AND MOVIES ARE REALLY POPULAR, AND APPARENTLY LOTS OF PEOPLE ARE SEARCHING FOR THEM EVERYWHERE.

When I watched the movie *Once Upon a Time in Hollywood*, I noticed that Brad Pitt wears a Champion T-shirt. I used to have one years ago, and seeing it again really brought back memories. I was thinking I'd like to get another, but now it's considered a vintage item and is quite pricey. Tarantino's very particular about things like that in his films.

Let me think. Marlon Brando's pretty cool. I like how his shirts are kind of well worn. James Dean looked great in *Rebel Without a Cause*, wearing that white T-shirt through the whole movie. And the actress [Mackenzie Phillips] who played the young girl, around twelve, in *American Graffiti*. She wore this kind of ill-fitting printed T-shirt, and the way the collar was frayed was indescribable. Shirts from Gunze, a Japanese shirtmaker, could never get that way and still look cool.

JAPANESE BRANDS ARE MORE PARTICULAR ABOUT HOW THEY'RE
MANUFACTURED.

Anyway, in the past you could only find models, or textbook examples, in American movies. Like in films about the Second World War—when it got hot the GIs

T

85 TOP: A restaurant I often go to in Honolulu, 12th Ave Grill

86 BOTTOM: A shirt from the famous old surf shop Local Motion in Hawaii

T

87 TOP: A shirt from the Ireland hurling competition cosponsored by Guinness

88 BOTTOM: The English surfing brand Saltrock

would just wear a T-shirt, right? Very cool looking. So it's not the T-shirt, but how they wear it.

I KNOW YOU LOVE JAZZ, AND I WAS WONDERING ABOUT JAZZ-RELATED T-SHIRTS?

I don't have very many. In the heyday of jazz, musicians dressed up for their performances. MJQ and Miles Davis, for instance, would look totally smart, decked out in snappy suits and stylish neckties. Wynton Marsalis has kind of inherited that approach. In the 1970s some black musicians wore Afros, as was the style at the time, but T-shirts never caught on. I think Chet Baker did an album where he wears a T-shirt, but I can't think of any others. T-shirt culture and jazz don't seem to click.

TWO YEARS HAVE PASSED SINCE WE LAST TALKED ABOUT T-SHIRTS. HAS YOUR COLLECTION GROWN A LOT SINCE THEN?

As I mentioned, Goodwill in Hawaii, where I buy most of the shirts, has raised its prices, so I don't buy so

many anymore. I'll buy something if the price makes sense, but quite often, I decide otherwise.

Yeah, I'd say so. It's a game, so you've got to have rules or else the game doesn't work. If there's no limit to how much you're willing to spend, it's kind of boring. I'll look at two hundred T-shirts before I find one that I may, or may not, decide to buy . . . and if you're going to examine things so meticulously like that, it takes a lot of time. But like I said, it's a game, so I do my best to examine them all [*laughs*].

YOU REALLY DIG DOWN DEEP FOR T-SHIRTS, THEN [*LAUGHS*].

Goodwill's so much fun. But it's really changed these days. The Salvation Army stores, too. I prefer the way they used to be. The world's getting tough, even for thrift shops.

I LIKE IT THAT YOU BUY THEM AT GOODWILL, AND NOT SOME FAVORITE USED-CLOTHING STORE.

The shirts I find are more fun that way. There aren't many good ones in Japan. Plus they're pretty expensive. Though I did buy a Ramones shirt from a Book-off store in Kyoto.

YOU LIKE TO LISTEN TO THE RAMONES?

I do, though all their songs have the same rhythm, so after a while I get tired of it. But I can't bring myself to wear that shirt outside. There are some limits when you get to be seventy [*laughs*].

HERE I'D LIKE TO SHOW YOU SOME OF THE SHIRTS THAT WEREN'T INCLUDED IN THE MAGAZINE SERIES. ONE THING THAT REALLY SURPRISED ME WAS THE NUMBER OF NOVELTY T-SHIRTS BASED ON YOUR WORKS.

You won't find me wearing those, either [*laughs*]. There are tons of them, piling up in my storage area. They made lots of the *Kafka on the Shore* T-shirts for the stage

production in France that Yukio Ninagawa directed. I think that shirt is pretty cool.

I'D LOVE TO RUMMAGE AROUND IN YOUR STORAGE AREA. WHEN YOU TALK ABOUT T-SHIRTS YOU'LL NEVER WEAR, IS THERE SOME HARD-AND-FAST RULE YOU FOLLOW? IN THE ESSAYS YOU WROTE, SEVERAL TIMES YOU NOTED THAT YOU'D NEVER WEAR A PARTICULAR SHIRT. COULD YOU TALK ABOUT THAT?

There are rules, and I make a clear distinction between the shirts I'll wear and the shirts I won't. The main thing for me is that I don't want to attract attention. To put it bluntly. I'd like to live under the radar as much as I can. I ride the subway, take the bus, walk around— I go to bookstores, the record store Disk Union, and so on. I don't want people noticing me. A T-shirt might look nice, but in my case, it's no good if it attracts attention. So my options are limited. There are lots of shirts that are really great, but they don't work for that reason. First of all, I don't wear T-shirts with written messages on them. Wear those and people will read the message, right? [*laughs*] And I can't have that.

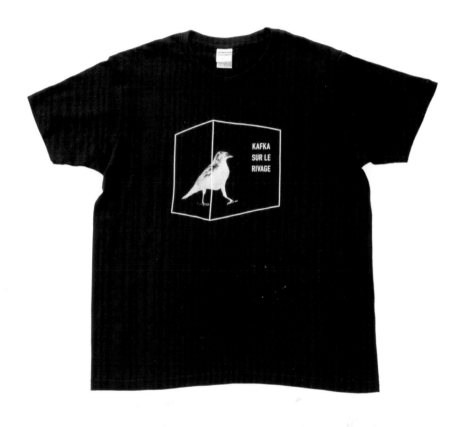

T

89 A T-shirt from the Paris stage production of *Kafka on the Shore*, directed by Yukio Ninagawa

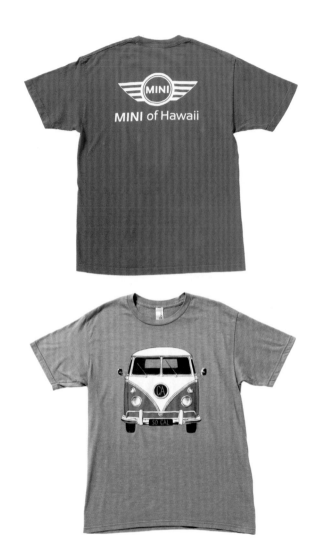

T

90 TOP: I got this shirt when I bought a Mini in Hawaii. Minis are the perfect car in Hawaii.
91 BOTTOM: A Volkswagen VW Bus. One of my favorite cars.

YOU MENTIONED THAT ONE KIND OF SHIRT THAT YOU WON'T WEAR IS A WHISKEY-RELATED SHIRT. BUT I UNDERSTAND THAT YOU ENJOY WHISKEY, EVEN AT HOME, AND I WONDERED IF YOU HAVE A FAVORITE BRAND.

Yes, I do enjoy whiskey. I like all kinds of whiskey, but ever since I visited the island of Islay, I like Laphroaig the best. I never get tired of it. It has its own unique flavor, and when I have to choose one brand over the others, it's almost always Laphroaig. There's a really nice whiskey bar in my neighborhood. These days I have highballs there a lot. I go there on Saturday afternoons. They have happy hour from 3:30 to 5:30, when there's a 30 percent discount on drinks.

WHEN YOU DRINK WHISKEY, YOU ALWAYS LISTEN TO JAZZ, RIGHT? IF SOMEONE IN THEIR EARLY TWENTIES WANTED TO HAVE A HIGHBALL AND LISTEN TO JAZZ, WHAT WOULD YOU RECOMMEND THEY LISTEN TO FIRST?

At home, yes, jazz is best. You don't have much choice, though, when you drink at a bar. Billie Holiday would be my choice, but I have no idea if young people would

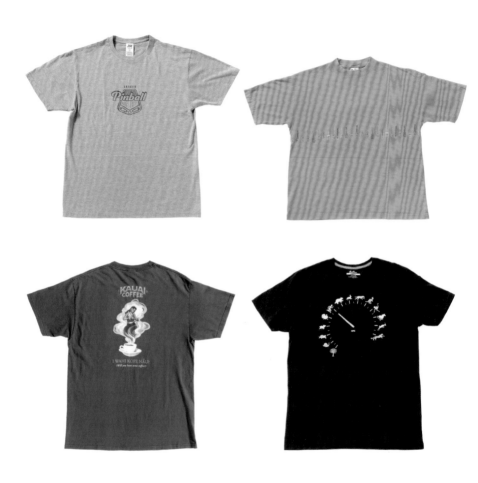

T

92 TOP LEFT: From the Pinball Museum in Krakow, Poland

93 TOP RIGHT: A ukulele T-shirt I found in Hawaii

94 BOTTOM LEFT: Kauai Coffee. One feature of my collection is the great number of shirts from Hawaii.

95 BOTTOM RIGHT: The design is of a speedometer with various animals. The fastest is the cheetah.

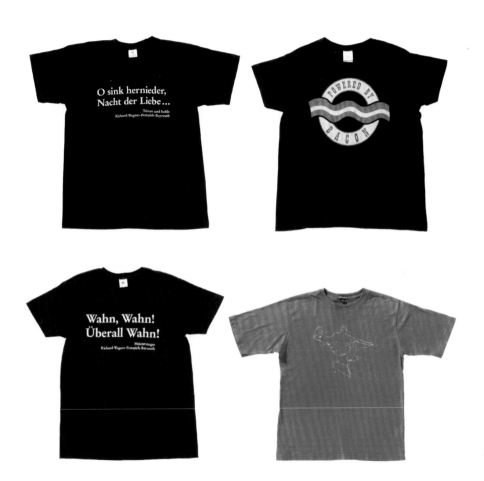

T

96 TOP LEFT: A line from a Wagner opera. I bought this when I went to the Bayreuth Festival.

97 TOP RIGHT: A must when you have a hamburger

98 BOTTOM LEFT: Another line from a Wagner opera. Only sold at the Bayreuth Festival.

99 BOTTOM RIGHT: I have a lot of surfing- and skateboard-motif shirts I've bought at Goodwill.

like her. Whenever I feel kind of worn out, I'll go to Pronto and have a highball of Jim Beam. A bit of a lowbrow way of drinking, but not so bad.

I THINK I GET WHY YOU DON'T LIKE WEARING T-SHIRTS THAT STAND OUT. BUT I DOUBT ANYONE EVER IMAGINED YOU DOWNING HIGHBALLS AT A CHAIN BAR LIKE PRONTO [*LAUGHS*].

When it comes to shirts that I will or won't wear— I don't wear rock concert T-shirts either. Though who knows, maybe wearing a Barry Manilow shirt now would be considered cool. A Carpenters shirt might work, too. They used to be considered tacky, but maybe not anymore.

THAT'S VERY POSSIBLE. PUT A ROCK T-SHIRT AWAY FOR A WHILE AND MAYBE IT'LL MAKE A COMEBACK.

Right—you set it aside for a bit. I wish I'd bought a shirt back when Bob Marley toured Japan and played at the Kosei Nenkin Hall.

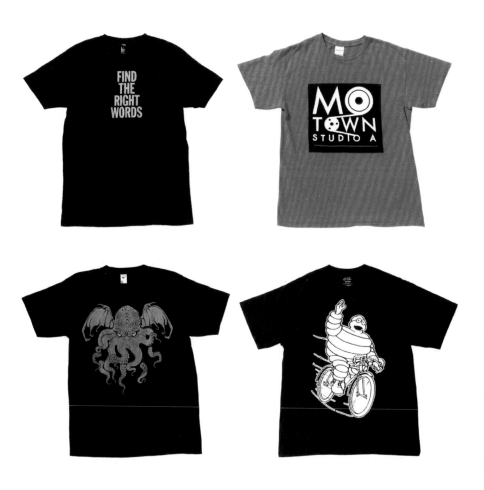

T

100 TOP LEFT: I received this at a book festival in New Zealand. I like the message.

101 TOP RIGHT: A T-shirt from the Motown Museum in Detroit

102 BOTTOM LEFT: If I wore this it'd be sure to attract a lot of attention, so I don't.

103 BOTTOM RIGHT: Bibendum, the famous Michelin Tire Man

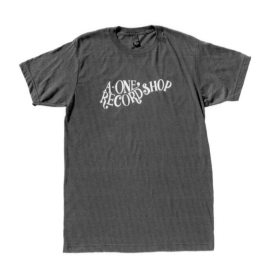

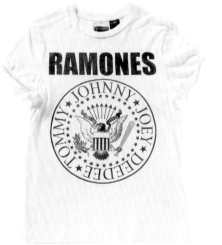

T

104 TOP: From the A-One Record Shop in New York, popular with DJs
105 BOTTOM: A Ramones T-shirt I found in Kyoto

AH, THE CONCERT WHERE YOU SAID YOU COULDN'T HELP BUT MOVE IN TIME TO THE MUSIC!

I would love to have a Talking Heads shirt, too. And the Tom Tom Club.

YOU LISTENED TO NEW-WAVE MUSIC, TOO? YOU REALLY ENJOY A LOT OF DIFFERENT GENRES.

I try my best to keep up. I mean, if you step away from music for a while, you lose track of what's going on. If you don't follow music for three or four years and listen to what's playing now, you can't figure it out. It all sounds the same. So I try to keep on listening so I don't get lost.

MUSIC AND FASHION ARE THE SAME THAT WAY. SO HOW DO YOU FOLLOW WHAT'S GOING ON IN MUSIC?

I go to Tower Records and spend half a day pushing all the LISTEN buttons and checking out all kinds of music [*laughs*]. It's really great. I'll usually find three or four CDs that I want to buy. I don't want as many as I used to, but if I listen carefully to those three or four

T

106 A novelty T-shirt from the New Yorker Festival I participated in in 2002

new CDs, I get a feeling for what's new in music. An overall sense of it.

THAT'S VERY TRUE. ARE THERE ANY SHIRTS AMONG THE TWO HUNDRED OR SO INCLUDED HERE THAT YOU'RE ESPECIALLY FOND OF, OR HAVE SPECIAL FEELINGS FOR?

This one here, the one that says TONY TAKITANI. After I bought this, I wrote a short story titled "Tony Takitani."

SO IT'S NOT JUST A NOVELTY ITEM! YOU BOUGHT THE SHIRT FIRST?

I bought the shirt and wondered: What kind of person is Tony Takitani, anyway? I imagined all sorts of scenarios and ended up with a short story. So it's definitely a memorable shirt. It says HOUSE D on it, right? I had no idea what that meant, but later on heard that it was a shirt for an election. Tony Takitani was running for the Hawaii House of Representatives as a Democrat. That's what the "House" and the "D" stand for. After the story was published and translated into English, I

got a letter from a man saying, "I'm Tony Takitani."
He said he lost the election that time. But now he's a
successful lawyer, and he invited me to come play golf
sometime. I'm not a golfer, though.

THAT'S SUCH A GREAT STORY. IMAGINE—A SHORT STORY COMING OUT OF A T-SHIRT.

I bought it in a small thrift shop while I was driving
around Maui. For a dollar. The whole thing was a
mystery at first, but once I wrote the story the mystery
was solved, and it even became a film later.

HURRAY FOR THAT T-SHIRT! I'M SURE YOU'LL CONTINUE WEARING T-SHIRTS, BUT DOES THE WAY YOU WEAR THEM CHANGE AS YOU GROW OLDER? I'D ALWAYS THOUGHT THAT ONCE I GOT A JOB, I'D GRADUATE FROM THEM, SO TO SPEAK, AND THAT ADULTS DON'T WEAR THEM—BUT T-SHIRTS ARE STILL ALL I WEAR.

I don't think age makes much of a difference. I keep on
wearing the same shirts as before. If I happen to put on
a shirt with a collar, my assistant at the office will ask,

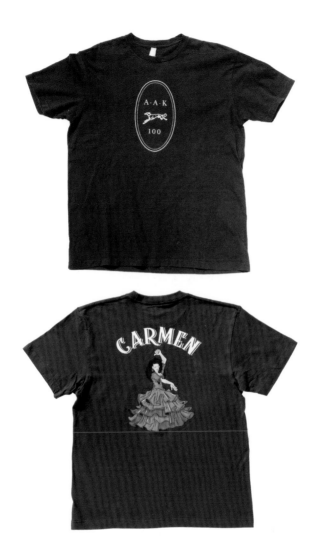

T

107 TOP: A T-shirt from the one hundredth anniversary of my U.S. publisher, Knopf
108 BOTTOM: A 2019 T-shirt from when Seiji Ozawa conducted a performance of *Carmen*

"Did something happen?" [*laughs*] Though you'll notice I do have a regular shirt on today. The T-shirt I have on underneath is one that Banana Yoshimoto gave me awhile ago. [*Mr. Murakami then peeled up his shirt to reveal the T-shirt.*] I like this one a lot. Of Lanikai in Hawaii.

THAT SHIRT DOES HAVE A LOT OF CHARACTER. WE HAVEN'T PHOTOGRAPHED THAT ONE YET [*LAUGHS*].

When I was affiliated with the University of Hawaii, I had office hours once a week where anyone could stop by. One time, out of the blue, Banana showed up and gave me the shirt, saying it was a souvenir. It's pretty comfortable, so I wear it a lot.

THAT'S WHAT'S GREAT ABOUT T-SHIRTS, HOW YOU CAN WEAR THE ONES YOU LIKE FOR SUCH A LONG TIME.

With this many, I never have to worry about what to wear in the summer. I could wear a different one each day and never wear the same one twice. Nice being a writer sometimes, right?

A NOTE ABOUT THE AUTHOR

Haruki Murakami was born in Kyoto in 1949 and now lives near Tokyo. His work has been translated into more than fifty languages, and the most recent of his many international honors is the Hans Christian Andersen Literature Award, whose previous recipients include Karl Ove Knausgård, Isabel Allende, and Salman Rushdie.

A NOTE ON THE TYPE

This book was set in a type called Baskerville. The face itself is a facsimile reproduction of types cast from the molds made for John Baskerville (1706–1775) from his designs. Baskerville's original face was one of the forerunners of the type style known to printers as "modern face"—a "modern" of the period A.D. 1800.

Composed by North Market Street Graphics, Lancaster, Pennsylvania

Printed and bound by C&C Offset, China

Designed by Anna B. Knighton and Chip Kidd